The MOBILE PHOTOGRAPHER

An Unofficial Guide to Using Android® Phones, Tablets, and Apps in a Photography Workflow

Robert Fisher

AMHERST MEDIA, INC. ■ BUFFALO, NY

Acknowledgments

I'd like to thank Craig, Kate, Barbara, and the rest of the team at Amherst Media for having the confidence to move forward with this project and the patience to work with me.

In addition, I'd like to acknowledge the app developers who went out of their way to answer questions and provide support for their software while I was writing the book and the companies that helped supply me with accessories for evaluation and inclusion in the book.

Copyright © 2015 by Robert Fisher.
All rights reserved.
All photographs by the author unless otherwise noted.

Published by:
Amherst Media, Inc.
P.O. Box 586
Buffalo, N.Y. 14226
Fax: 716-874-4508
www.AmherstMedia.com

Publisher: Craig Alesse
Senior Editor/Production Manager: Michelle Perkins
Editors: Barbara A. Lynch-Johnt, Harvey Goldstein, Beth Alesse
Associate Publisher: Kate Neaverth
Editorial Assistance from: Carey A. Miller, Sally Jarzab, John S. Loder
Business Manager: Adam Richards
Warehouse and Fulfillment Manager: Roger Singo

ISBN-13: 978-1-60895-823-8
Library of Congress Control Number: 2014944596
10 9 8 7 6 5 4 3 2 1

Check out Amherst Media's blogs at: http://portrait-photographer.blogspot.com/
http://weddingphotographer-amherstmedia.blogspot.com/

Contents

About the Author

 Robert Fisher is a commercial and fine art photographer and freelance writer based just outside of Toronto, Canada. His love of photography began nearly twenty years ago when he was first exposed to the impressionistic style of photography. This style captivated his imagination and served as the red pill for his journey into the photographic rabbit hole.

Robert holds an honors Bachelor of Administration degree from Brock University in St. Catherines, Ontario. His photographic knowledge has been gained through trial and error, asking questions, and informally studying photography and photographic techniques.

He has traveled as far as the Czech Republic to cover events and has held several solo and group shows. His work has also been exhibited in several galleries. Robert has also leveraged his education in business to publish several articles in finance industry publications.

Outside of photography, Robert is an enthusiastic and experimental amateur chef, a gardener, a player of really bad guitar, and owner of two adopted dogs he affectionately refers to as The Idiots.

Introduction

May you live in interesting times.—Unknown

There is much debate about the origin of the above quote. There really is no debate though that, as photographers, we are living in very interesting times.

In just over a decade since the first widely used digital single-lens reflex (DSLR) camera, the Canon 10D, was introduced the world of photography has undergone a revolution. The roles of film and digital imaging technology have been reversed 180 degrees. We now have high-quality DSLR cameras that can produce stunning still images as well as capture very high-quality video capable of being used in Hollywood productions. A television network in Sweden used D800 cameras to go live-to-air for a studio soccer show during the 2012 Euro championships.

The last five years of that decade have seen another revolution in digital imaging: the smartphone. Smartphones, with their puny 1 or 2 megapixel cameras, burst onto the scene with the iPhone and the first Android phones about five years ago and changed the

Image I.1 ▼ Can you smell it? Freshly roasted coffee at St. Lawrence Market in Toronto, ON—a photographic cornucopia. Nikon D800, ISO 640, ¹/₂₅ second, f/2.8. Initial RAW conversion in Photo Mate Pro with final adjustments in Photoshop CC2013.

world of photography. Those first smartphone cameras were not very good, of course, but that didn't matter. People were happily snapping away and posting to this new thing called "social media" instantly. The cameras improved along with the capabilities of the phones, and carrying a single device instead of two—a phone and a camera—became possible. Smartphones began to supplant small point-and-shoot cameras as the device of choice for snapshooters everywhere. Not just still photos either, but video as well.

Smartphones began to supplant small point-and-shoot cameras as the device of choice for snapshooters everywhere.

In early September 2013, both Acer and Samsung announced mobile devices that are capable of recording 4K video. That is a tremendous leap forward in technology. While there are limitations, such as a single framerate of 30 frames per second, and while we should not expect the video captured by these devices to be cinema-quality, the fact that such small devices costing well under $1,000 can do something that high-end DSLRs costing three to ten times as much cannot do is intriguing to say the least. Mid-October 2013 saw two new mirrorless interchangeable lens cameras brought to market by Sony. What's so interesting about that from a mobile standpoint? Both have WiFi connectivity built in. However, both also include Near Field Communication (NFC) connectivity. Sony also introduced its own camera control app and with the inclusion of NFC, connecting the phone to the camera can be done simply by touching the two devices together. Two days after the Sony announcement, Nikon released information on a new D5300 DSLR that had built-in WiFi and a new companion smartphone app that would allow the user to control the camera remotely. In early 2014, Fuji introduced the X-T1, and it, too, has built-in WiFi and a companion mobile app that allows users to control the camera from a smartphone or tablet.

In later October 2013, perhaps the biggest announcement yet in mobile imaging came from, what some may consider, a fairly unlikely source: Nokia. Nokia announced a trio of new devices but one, the 1520 6-inch "phablet" model was the first mobile device to capture RAW images. It uses the Adobe open-source DNG spec for this. A firmware update also brought DNG capture to the flagship 1020 phone. This isn't Android, you say? True. But it's still a significant development in the mobile photography game, and it will likely mean that Apple and Android developers will have to up their games going forward.

Mobile is the future, and the future is now!

Not long after the smartphone revolution, another technological innovation hit the market: the tablet. A device we didn't even know we needed has now found its way into the lives of tens of millions of people. And not just one. Some people own and use more than one tablet. I do.

I'll relate a little anecdote. For years, my mom had one of the "old school" flip phones. Some of her friends would show her their iPhones and what they could do with those phones. She started to become interested in my smartphone and decided she might like to have one, so I gave her mine when I upgraded. Then, after having been told how great e-readers were but resisting getting one (my mom is a voracious reader), she decided she might want to try one, so I bought her one as a Christmas present. Unfortunately, I made a less than optimal choice in the one I bought, as it had a very poor WiFi antenna—there was no way to know that ahead of time, as it was a brand-new model and there were no reviews available—and wouldn't connect reliably to the home network. She decided she wanted a better one. I told her I'd get her a Google Nexus 7 and she said no, that she felt she'd like a 10-inch model for doing things like e-mail, playing games, and reading the newspaper online, and she'd keep the 7-inch tablet to be used just as a reader. In under a year she went from having no smartphone and no e-reader/tablet to having a smartphone, a 7-inch tablet, and a 10-inch tablet. I created a monster!

Tablets, too, come with cameras and can capture still photos and video. It is not uncommon to see tourists taking pictures with their smartphones in a place like Niagara Falls. A friend and I go to Niagara Falls once a summer for a day of "schlock shooting"; Niagara Falls, Ontario, being the schlock capital of Canada. What struck me, in the summer of 2012, was the number of people taking pictures or video with a tablet. They were using the tablet to find tourist attractions or points of interest because of the larger screen, then using the camera in the tablet to record their memories.

With the booming popularity of smartphones and tablets for photographers both casual and serious, a profusion of applications or "apps" that could run on these devices and let people apply funky filters and "old style" film looks to their pictures hit the market. The Instagram generation was born.

But are these tablets and smartphones just for fun? Can serious, professional photographers—not to imply that professional photographers aren't fun! We are; we really are!—or advanced hobbyists use these things in their day-to-day photography lives? Absolutely!

Dig a little deeper into the app worlds of both Apple and Android and you will find a host of applications that can make a photographer's life easier. Tablets and the hardware accessories available to use with tablets make it possible to leave a laptop at home when going on the road. You can now easily review and edit images, including RAW, on your tablet and store them on small, wireless hard drives. That's right. Wireless hard drives! Who would have thought that when the 10D first hit the market? It's possible to connect tablets or phones to projectors for making presentations. About the only thing a laptop may be needed for now is doing a live software demonstration. When discussing apps as we move through the book, I will be referencing and describing the apps that I have found to be the better ones available. It is simply not possible to discuss every app for a given purpose, and while I have evaluated many, I may have missed some. If you have an app that you use that is not discussed

Images I.2 and I.3 ▲ Typical Niagara Falls schlock.

in the book and you like it, I would be happy to hear about it. You can post about it onto the Facebook Page that has been set up for the book at facebook. com/TheMobilePhotographerBook.

There are also other pieces of hardware that can be used with tablets and smartphones to increase useability of these devices for photographers. Carrying a tablet with well-prepared images can take the place of a bulky, printed portfolio in many situations now. And the instant ability to show someone a portfolio on a high-quality smartphone or tablet screen presents tremendous opportunities to the working photographer. There is something special about a well-made print and a high-quality print portfolio, no question.

But there is also something very compelling about a high-resolution, backlit screen that can make images pop unlike a print.

Apple and its iDevices do seem to get most of the attention. But pretty much anything that can be done on an Apple device can also be done with Android, and some things can be done on Android that can't on Apple. Android is going to be the focus of the rest of this book. In some markets, Android devices are outselling Apple. It used to be the feeling was that Apple was for creatives and Android was for hackers. Not so. Just as in the desktop world it's not true that Apple is for creatives and Windows is for people with a bent for masochism. Well, that may actually be true, but the capabilities of the two platforms are not any different (confirmed Windows masochist raising his hand here). I don't want this to be a one vs. the other type of discussion. Most people have settled into a particular camp and are happy with that choice. And if you've made the Apple choice, I'm sorry (OK, last jab at Apple. Well, probably not.) Just as we have with desktops and laptops. Just as we have with our DSLR systems. I'm an Android user. There are lots of others out there. I tease my Apple-loving friends by saying that when it comes to the iDevices, idontcare. That's not really true though. Just like Nikon or Canon, Windows or Mac, Android or iDevice is just a tool. It is what you do with that tool that makes the difference, and that is what we are going to concentrate on in this book.

The term "mobile photographer" can mean many things. On first blush, it could be as simple as using the camera on your smartphone or tablet to take pictures. Millions of people are doing this, every minute of every day. That is not what this book is about. There are many other books on the market about taking pictures with your smartphone and using some of the fun apps to edit and apply effects. Mobile could also mean that the photographer is out and about.

Image I.4 ▼ Vines growing over a window in the Kensington neighborhood of Toronto, ON. Nikon D700, ISO 200, ¹/₁₂₅ second, f/8. RAW conversion in Photo Mate Pro with final adjustments in Photoshop CC2013.

Certainly that applies to most all of us. Not many of us get many good photos from behind our desks. Not many of us can make a living sitting behind our computers. We have to be mobile. Mobile can also mean the ability to change and adapt quickly. Going back to the quote at the beginning of this section, we do live in interesting times and we do need to adapt quickly. The film shooter can't make much of a living any longer, for the most part. Unless you are someone like Dave Burnett, you can't shoot the Olympics with a 4x5. He does use digital too, by the way.

That is really at the heart of what this book is about: Adapting and changing to the new paradigm that we, as photographers, face. Adjusting our workflows and using the available technology to help us work more efficiently and effectively. Lightening the load when we travel so that we can get that bag into carry-on rather than having to check it. Being able to overcome limitations that manufacturers may build into our cameras, such as the infamous Canon three-shot Auto Exposure Bracketing sequence. Being able to get our cameras to do things that help us adapt to the changing needs of the photo-buying, and video-buying, clients. Enabling us to use tools we already have, like smartphones and tablets, and not have to go out and buy yet more expensive pieces of gear so that we can do our jobs.

Over the next several chapters, I'll work through a variety of topics from choosing a tablet or smartphone to compiling a portfolio to be hosted on an Android device to reviewing, editing, and storing images, to apps for increasing productivity.

What this book will not be is an instruction manual for apps and hardware. I will provide screen shots of menu layouts and provide the steps I use in doing certain tasks, but the instruction manual for your particular Android device(s), instructions, and FAQs for other hardware and apps, will still be your best bet to get to know them better. That and hands-on experience.

When I provide screen shots of desktop editing software as part of a workflow, I will be using Lightroom 5 or Photoshop CC. In certain parts of the book

I will describe step-by-step workflows for doing tasks in these programs, but this isn't an instruction manual for Lightroom or Photoshop. I am assuming a decent working knowledge of one, or both, of these programs on the part of the reader. If I do something or use a command you are not familiar with, you will have to research it. There certainly are other image-editing programs available, and some of those are very good. Some of the techniques discussed in relation to Lightroom or Photoshop may be able to be done in other digital darkroom applications. I am an Adobe user and most of the photographic community is as well, so I'm going to keep the explanations and examples to Adobe products.

That is what this book is about: Adapting and changing to the new paradigm that we, as photographers, face.

I'll conclude with a big caveat: Hardware changes quickly, with new phones and tablets being introduced at an amazing pace. Even just about five years into this technological revolution a level of maturity has hit the marketplace and new devices, for now, are more evolutionary than revolutionary, with a few exceptions. There will still be new and better coming along, just as there is with cameras. The apps available will continue to grow in number and be improved upon over time too. The state of play I discuss in the rest of the book is as I write. Hopefully things won't change too much in the time between now and when the book is released. If they do, then a second edition may be in order. In the case of one app, I've had to rewrite the discussion on it several times because it has undergone a number of significant revisions just in the time I've written this book.

With that out of the way, let us move on to becoming true mobile photographers.

1. Choosing a Mobile Device

The Android landscape is a bit different from Apple. In Apple-land, you've got a single supplier and you take what Apple gives you—for better or worse. In Android-world, there's a cornucopia of choice. That is both good and bad: It's good in that you have many different manufacturers and configurations to choose from, and it's bad in that it can be difficult to figure out the better from the not-so-good options, and there are definitely some not-so-good options out there. It doesn't always apply but, in general, higher-priced means higher quality, more options and functionality, better components (particularly the screen), and a better overall device.

Choosing the right phone and/or tablet is important. The wrong one could mean a less than pleasant user experience, a poor-quality viewing experience, and an inability to use some of the hardware and software that will be discussed in the rest of the book.

▶ Choosing a Phone

For the best screens, most features, and best capabilities, it should not come as a big surprise that you are going to want to gravitate to the higher-end devices from the more mainstream manufacturers.

You want to look for a phone that has at least the following characteristics:

- A screen resolution of at least 1280x720 pixels will provide for crisp image viewing. Phones with full-HD screens are starting to hit the market, and the number of those will increase over time.
- Super AMOLED or Super LCD2 screens produce more vibrant color and give more "life" to photos and video. These screens are better for viewing in

outdoor conditions, although none are particularly good in that setting. Super AMOLED screens tend to produce colors that are a bit more saturated, but both can produce terrific color and render very fine shades of gray. Some phones have IPS screens, but these tend to wash out a bit more outdoors, which is odd for an IPS panel.

- The ability to act as a USB host will allow the phone to be used with some apps for controlling the camera remotely. USB Host mode allows the device to provide power to a USB port and to send information out through the USB cable to the camera. For this functionality, sticking to the higher-end Samsung devices is probably your best bet. Samsung seems to be on board with enabling USB Host in its top-of-the line devices. Other manufacturers are hit and miss. HTC is known for not enabling the functionality in its phones.
- At least 16GB of storage. If you use your phone for taking a lot of images with the on-board camera, then more internal storage or the ability to use a memory card will be important. Not all phones are available with an accessory memory card slot.
- At least 1GB of RAM. As with your laptop or desktop, RAM is a key driver of performance.
- A fast dual-core or quad-core processor. Quad-core processors are becoming more common. The better the processor, the faster the phone will be in performing tasks. Many phones and tablets use ARM processors. These can be very fast, but they are only able to complete a single task at a time. Intel processors do not have this limitation. Multi-core processors are important in devices with ARM chips due to this processing limitation.

- 4G/LTE cellular connectivity will provide for the fastest data-transfer speeds. Older 3G networks are quite a bit slower than the newer 4G/LTE spec which, in some cases, can be faster than wired broadband speeds in your home.

It can seem that there is a dizzying selection of phones on the market. Each manufacturer has multiple models to choose from. As I alluded to earlier, choice cuts both ways. When you begin to look more carefully and have done research, the likely candidates begin to separate from the crowd. What it will come down to is your personal preference. Do you have good or bad experience with a particular manufacturer? Do you like the layout of the user interface that the particular manufacturer installs over the stock Android interface (a custom "skin")? Do you like the shape and feel of the phone in your hand? Many of the current, better-quality phones now use light-emitting diode (LED) backlights. LED is an improvement over older fluorescent lighting and provides a wider color gamut and better overall color and contrast. Many of the better phones also make use of Corning's Gorilla Glass, a very tough, scratch-resistant glass that works well on these devices. Gorilla Glass 3 is the latest variant, and Corning claims it's even tougher and has better color reproduction than the original, along with being lighter and thinner and improving the touch experience.

Unfortunately, a lot of retail outlets do not let you test the phones to see how they work and look. The phones come with a stick-on simulated screen. This makes choosing a phone a bit more difficult, but if you do your research in advance, reading credible reviews and viewing videos of the phones in use by reviewers, you can get a good sense of whether a particular phone will be right for you. The employees in the store may have the latest phones for their personal use. Ask if they will let you check out their phone. If you want to check USB host functionality, bring your camera and a USB cable, along with an OTG cable, download one of the apps discussed later in the book, and try it out. You have about 15 minutes to return an

Hacking the Android OS

With some phones, it is possible to do some things to get additional functionality. You can go through a process called "unlocking the bootloader," which will allow you to install custom versions of the Android OS. You can also "root" the phone, which will allow you access to functions you otherwise wouldn't have. Be advised, these procedures are not for the faint of heart. Even if you have some idea of what you're doing, it is quite possible to turn your phone into a very expensive paperweight (a.k.a. "bricking the phone")—don't ask me how I know that. (Where's that rolling eyes graemlin when you really need it?) With that warning in place, I take no responsibility if you decide to try and hack your phone (or tablet) and end up with a bricked device.

app and get a refund on the Google Play Store. If you take longer than that, you will probably have to pay the sales employee for the cost of the app.

▶ Choosing a Tablet

As with Android phones, there is a plethora of tablets available to choose from—even more than for phones. You'll choose between manufacturers and models and size as well, with the newer 7-inch and 5 to 6-inch "phablet" variants widely available.

Whether you opt for a 10- or 7-inch screen, or one of the in-between "phablet" sizes, will be a matter of personal preference. Maybe you'll get one of each! The 10-inch screens are better for viewing and editing images. If you are using apps for controlling the camera, a larger screen will make the controls more easily visible, and there will be less chance of pressing the wrong thing. The 7-inch screens are a compromise between the smaller phone screen and the full-size tablet. These are less optimal for viewing images, but if you want to do something such as use the tablet as an external monitor when shooting video and have the monitor attached to your video rig, it may be more suited to that purpose than the larger versions.

Most of the same qualities mentioned earlier for phones apply to tablets as well. With tablets, however, an IPS panel is a good idea. Some of the tablets have variants of IPS such as PLS, and these too are desirable. The larger screen that will be used for reviewing images makes the tradeoff of slightly reduced visibility outdoors in bright light a good one. A few tablets have what is called IPS+—the Asus TF-700 is one—and this allows you to turn the IPS+ feature on when outdoors to help improve visibility. The IPS+ mode increases brightness of the backlight. It does work, as I have the TF-700 and can attest to its usefulness. It's not perfect. In very bright light, the screen is still going to wash out somewhat, but it is still useable, unlike with a regular IPS screen or a lower-quality display. In IPS+ mode at full brightness, the screen of the TF-700 puts out a whopping 600 cd/m^2 of brightness!

Tablets often come in 16GB, 32GB, and 64GB variants of internal memory. Because you may use the tablet to store images from your digital camera, where you probably won't on a phone, the larger-capacity memory is preferable. I would suggest 32GB as a reasonable amount of internal storage. The ability to use an accessory memory card, typically a microSD card, is also of greater importance when using a tablet for this reason. We will be looking at external storage later in the book. There are some tablets coming on the market now with larger-capacity storage. The price of these is quite a bit higher. You pay a premium for the extra internal storage compared to adding the same amount of storage via a microSD card. As we will see later in the book, I don't recommend internal tablet storage as primary storage, so the higher capacity really isn't worth the bigger price in my view.

Screen resolution is moving into the full-HD (FHD), 1920 pixels in horizontal resolution, and higher, spec in an increasing number of devices. This resolution will provide for very crisp photos viewed on the screen. While images can look "good" on a screen with less than FHD resolution, I think you will be more satisfied with the look of the higher-resolution screen. I would not recommend going to a higher resolution than FHD. There are a few of these higher-screen-resolution tablets coming on the market as of late 2013. The problem with higher-resolution screens is that your icons and text become smaller. That can make reading text or icons difficult. A higher screen resolution means you can also host larger-size image files for your portable portfolio, but this takes up more storage space. On-board storage space is not increasing with the higher-resolution devices, so you will be eating up more of that precious resource with those higher-resolution images. At this point, I believe FHD screen resolution is about right.

The ability of the tablet to act as a USB host is important for plugging in card readers and using the tablet to control the camera. With the better-quality, higher-end tablets, this should not be an issue. Some tablets limit the amount of power that a USB device can draw. Apple does, which is why some of the camera-controlling apps aren't available for Apple devices. This could affect the ability to use some USB-connected devices. It is something to make a part of your research as you are looking for a tablet. I have no issue with my SanDisk Extreme USB 2.0 card reader and my TF-700 tablet nor my Nexus 7 II. The camera controller apps I've used also work well on my tablets. The same consideration applies here as with phones with respect to USB host functionality and trying to load custom versions of the Android OS. Do it with extreme care.

Lastly is the consideration of whether to buy a tablet that has cellular connectivity or is WiFi only. Again, this will be somewhat a matter of personal preference, but I do not believe cellular connectivity is a big necessity when it comes to tablets. The growing availability of public WiFi makes cell connections for tablets less important. Also, when you are carrying your tablet, you are probably also carrying your phone. Many smartphones allow for the device to be used as a WiFi hotspot, and you can then connect your tablet to the hotspot you created with your phone to get Internet access. Some cellular data plans may put limits on tethering, wired or WiFi, depending on

the type of plan you have. If you are going to use your phone as a WiFi hotspot for getting connectivity with your tablet, check with your cell provider to make sure your data plan allows you to do so.

▶ Locked vs. Unlocked

If you are buying a phone or cell-enabled tablet from a cellular provider, you often don't have a choice of whether the device is locked or unlocked. Most cell providers lock the device to their own network as a way of keeping you tied to them for the full term of your contract. The phones and tablets may be sold at a substantial discount and the cellular companies need the revenue from your voice and data plans to make up for that subsidized price.

You can buy unlocked devices, but you will pay full price for these. Some cellular providers will unlock a phone for you but often charge a not inexpensive fee to do this. Some providers will only unlock a phone after the subsidized contract has expired.

Traveling with a locked device means you may incur significant roaming charges if you use your phone or tablet in another country. Many providers will sell you a plan to use while traveling that cuts down, somewhat, on these additional costs, but the plans are not inexpensive and you're still subject to the full charges if you exceed the plan.

There are websites you can access that will sell you an unlock code for your device. I provide no warranty or assurance that these are reputable or genuine or that you won't end up turning your phone or tablet into a paperweight. You need to do your own due diligence if you intend to go this route. I have done it with my phone and have no problem.

Generally the process involves buying the unlock code and inserting a SIM card from a provider other than your own. The unlock code is tied to the specific phone, which is identified with the IMEI (International Mobile Equipment Identity) number. You will have to provide this number to the vendor to get your unlock code. When the phone detects the presence of a non-network SIM card you will be prompted for the

unlock code. You type into the phone the unlock code you bought, and it will remove the network restriction, allowing you to use the non-network SIM card. Unlock codes vary in cost depending on the phone. Mine cost about $14. You don't need to buy any sort of pay-as-you-go data plan. Simply the presence of a non-network SIM should prompt you for the unlock code. My provider charges at least $50 and won't unlock the phone while the customer is under a subsidized contract.

With your device unlocked, you are able to buy pay-as-you-go plans in other countries. You can buy voice and/or data plans and you only pay the cost as if you were resident in that country. No roaming charges. You can top up the plans if you use up your allotment. You will have a different phone number while you are traveling, but cellular costs can be significantly reduced with an unlocked phone.

Image 1.1 ▶ Small waterfall in Chutes Provincial Park, Massey, ON. Shot on a Canon 5D, ISO 50, .3 second, f/11.

2. Mobile Accessories and Apps

Once you've chosen your Android(s), it's time to accessorize. Accessories! Fun, right? This is to geeks like shoe shopping is to some women. In this chapter, we'll look at some of the basic hardware and software items that you may want to add onto your phone or tablet to make use easier. We won't be getting into the photography-related software; that will come later. For now, we are going to concentrate on improving the stock functionality of the devices. I'm going to discuss the apps I use and, in some cases, a few alternatives. There are many other apps for all of these functions available, so if you have one you like better, use it (and let me know about it on the book's Facebook page as well).

▶ Cleaning

This may be the most important accessory you get for your tablet or phone. These are touch devices, after all. Touch screens get mucked up very quickly with fingerprints and smudges. Presenting a heavily smudged screen to a prospective client to have them view your portfolio isn't going to put forward a great first impression.

You bought that high-pixel-density tablet or phone for a reason. Why do something that will impede the viewing?

I have yet to buy a phone that comes with a cleaning cloth. Of the three tablets I have used, one did and two did not. If your phone or tablet didn't come with a cleaning cloth, buy one. A good microfiber cleaning cloth is all that should be necessary to clean the glass. The same kinds that are used for cleaning lenses will work. On the subject of lenses, don't forget to clean the camera lenses on your phone and tablet too. Those will get just as smudged as the screens.

You can get stick-on screen protectors. I would advise against one of these. They offer a matte finish, which helps with glare, but it will also impair the sharpness of the display. You bought that high-pixel-density tablet or phone for a reason. Why then do something that will impede the effect of it for viewing?

▶ Keyboards

Hardware Keyboards. Of course, these devices come with pre-installed software keyboards to be used for typing. These are okay but not great, and certainly not something you'd want to use for long periods of time. There are options.

If you use Asus Transformer tablets, you can look into the keyboard dock that's available. There are a couple other models from other manufacturers that have keyboard docks available too. The tablet plugs into the dock and then functions not unlike a laptop or netbook. The main drawback of this is that the tablet is top heavy, so if you have the screen angled even just a bit off of vertical toward the back, the whole kit can tumble over on you. The upside of the keyboard dock is that it provides a protective cover for the tablet when closed, acting like a laptop. Some of the docks have on-board batteries that will extend the usage time of the battery in the tablet. Some also have additional ports, such as full-sized USB or full-sized SD card slots.

If you are not an Asus user or do not want to go for the Asus keyboard, you can turn to one of the other

Image 2.1 ▲ Fresh pasta waiting to be purchased at St. Lawrence Market in Toronto, ON. Nikon D800, ISO 1250, $\frac{1}{160}$ second, f/2.8. Initial RAW editing in Photo Mate Pro with final tweaks in Photoshop CC2013.

keyboard options available. These connect with the tablet via Bluetooth. I'm currently using a KeyFolio Pro 2 Universal from Kensington that came with a carrying case. The keyboard is held into the case with magnets. There is a loop for holding a stylus. The keyboard offers no ports except a microUSB for charging. The battery life is excellent on the keyboard. The tablet can be positioned at a variety of angles and is held in place with rubber corners that attach to the folio case with Velcro. What I don't like about it is the rubber corners that hold the tablet in place are a bit bulky and don't hold the device firmly. It is not going to fall out, it's just not a snug fit. There is no cutout in the back for the main camera. Being a universal case, it is intended to hold a variety of 10-inch tablets, not any one specifically. The lack of a camera cutout really is not important because I would not be taking

pictures with the tablet in the case anyway. On the upside, the rubber corners provide ample protection for the tablet when closed in the case so it is not rubbing against the keyboard. The whole thing is a bit bulky; it is still much smaller and lighter than a laptop though. I have also tried another brand's case/keyboard combo (that company will remain nameless) that was much less expensive than the Kensington, and with these accessories you get what you pay for. It did not work well at all, although the case is rather nicely designed, but despite the description, it was not designed for my tablet and the keyboard response was awful. Based on my own experience, I'd suggest sticking with higher-end options from well-known brands to help ensure quality and reliability.

Finding a case and keyboard that are designed specifically for your model of tablet will help keep the

package a bit smaller and better fitting. It should also provide a cutout for the rear-facing camera so you can use it while the tablet is in the case.

Personally, I would not buy a keyboard that did not come included in a case. A standalone keyboard is just another piece of loose kit that needs to be dealt with. Having a nice, neat package for everything is the better approach in my opinion.

The typical software keyboards on mobile devices aren't really that good. The functionality is a bit of a mess.

The Bluetooth keyboards are a bit smaller than a standard laptop keyboard. The comfort level for typing, I find, is fine—and I have fairly large hands with long fingers. I would not want to write an entire book using one, but making social media entries, writing a blog post, keywording photos, and typing emails or other short documents is fine. I have written sections of this book with one.

Software Keyboard Apps. We have options for hardware keyboards and we have options for software keyboards. To be honest, this was a fairly late discovery for me. For quite a while, I thought I was stuck with the software keyboard that came installed on the phone or tablet. Oh, how wrong I was.

The typical software keyboards on mobile devices aren't really that good. The functionality is a bit of a mess. The layout varies from manufacturer to manufacturer. Some of them require going to a second screen for number keys or punctuation. They're just not overly useful.

I'm not even going to bother going through some of the different options. I'm just going to tell you to go and download the Hacker's Keyboard from the Google Play Store. I thought I had landed in keyboard nirvana when I started using this. It's laid out just like a regular hardware keyboard. It is a full 5-row layout and it can be customized quite extensively. Typing with this keyboard is so much more pleasant than

with the stock keyboards. Just go download it on your tablet and your phone. It works well in both screen-size configurations and it works on the 7-inch tablets too. On phones, with the smaller screens, the keys are a bit small and cramped tightly together, so it may not be as useful on phones.

▶ Cases

Even if you get a hardware keyboard-and-case combination, chances are you are still going to want a second case without the keyboard. The case-only option is useful when you are carrying your tablet around and using it for regular day-to-day things like reading e-books, surfing the web, writing and reading email, and using social media.

You have two basic options: the folding case and the sleeve. I find the folding, folio-style case more to my liking, but this will be an area of personal preference. The folding cases will typically give you the ability to prop the tablet up for easy viewing, which the sleeves will not. Folio cases will generally be made model-specific and have cutouts for the various ports and cameras. Sleeves are just protective and not really utilitarian otherwise.

Cases, either folio or sleeve, come in a wide variety of designs and colors so you can show off a bit of your personality with your choice of case.

There are also protective skins available for phones. These too will be model-specific, so they will have the necessary cutouts for the various buttons and cameras. I never used one until I got my latest phone which I found, due to its shape, was a bit more difficult to hold onto while typing. If you are prone to dropping your phone, a case may be a good idea.

Like with the tablet cases, phone skins come in all manner of colors and designs so you can show off a bit of your personality here, too, if you want. If you are really clumsy, something like an Otterbox case may be more your style—or need. But please, I beseech you, do not buy one of those cases that has a protective plastic front or use one of those stick-on screen protectors. You are buying a device with a brilliant, high-

resolution screen and paying a good dollar for it. It is going to make your images look fantastic! Do not ruin it by putting a few pennies worth of plastic on top of it that will degrade the screen quality.

▶ USB Connectivity

In order to use your phone or tablet to control the camera, use a card reader or any other USB devices, you are going to need a powered USB port. This is what I was referring to in chapter 1 about the device acting as a USB host. Phones and most tablets do not have a full-size USB port. Instead, what many phones have is a microUSB port that is used for charging, and tablets may have the same port or use a larger, multi-pin port for charging. If your tablet has a microUSB port, that may work, and if not, the charging port is what you will need to use.

You want to look for devices called On-the-Go (OTG) USB adapters. I have two—one for the 10-inch tablet that plugs into the charging port and one for the phone and 7-inch tablet that plugs into the microUSB port (**image 2.2**). With these adapters you can connect a USB cable and information can be transferred to the camera using the phone or tablet as an advanced remote release. The apps that will be discussed later allow access to a wide variety of camera functions remotely, including in one case focusing during video shooting. The USB connection will also allow you to connect a memory card reader to a tablet for transferring images to the tablet or external hard drive.

▶ Organizing Parts and Pieces

Speaking about cables and other accessories, it seems a good time to talk about keeping all these things organized. With all the various devices and cameras we carry, even when not using mobile solutions, it can be difficult to keep the various components and parts straight. What grip goes with what camera? What battery goes with what grip? What cable goes with what camera or phone or tablet? Rummaging through a kit bag to try to find the right pieces that go together can be time consuming and frustrating.

Image 2.2 ▲ OTG Connectors.

I have a simple solution that works for me. Maybe it, or something similar, will work for you. Nail polish. Yes, you read that right. Nail polish. I put small dabs of nail polish on all the various pieces that go together. My D800, grip, batteries, and USB cable are one color. My D700, grip, batteries and USB cable are another color. My WiFi hard drives and the DC cables for charging are other colors. I find it really helps in locating what I need when I need it.

You don't need an expensive product. The ones I use cost about $2/bottle at a local drug store. You want to make sure to use bright colors so that it shows up against the black of the various components. Dark colors would largely blend in with black and be difficult to see. For the men reading this, if you feel awkward going to buy nail polish yourself, ask your wife, or girlfriend, or daughter to do it for you. If you don't have a wife, girlfriend, or daughter, then you are just going to have to suck it up. Or come up with a similar solution other than nail polish.

▶ Mice/Trackpads

You might wonder why you would need a mouse or trackpad when you're using a touch device. That's a fair point. I find that when I am doing work on a spreadsheet to do a budget for a quote to a client, or when I'm reviewing/editing photos, doing keywording,

Image 2.3 ▲ Logitech trackpad.

Image 2.4 ▲ PowerTrip by PowerStick.

and other similar tasks, I prefer to work without touching the screen. The need to move from a keyboard to the screen and back, for me, is a bit of a wonky workflow. Likely that comes from years of working with traditional mouse devices and laptop trackpads. It's the workflow I'm comfortable with. It also helps keep the screen a bit cleaner.

Given that, there are some options for accessory pointing devices out there. There are plenty of wireless mouse options available. The biggest problem with these is that they use a USB dongle for WiFi connectivity. If you have a USB device already connected to the OTG adapter or are using the USB port on a

docking station, you have no place to put the USB dongle for the mouse. That leaves us with Bluetooth.

There are a few Bluetooth mouse devices on the market. What I settled on was a Bluetooth trackpad device from Logitech (**image 2.3**). It's branded as "for Apple," but that's only because it is Bluetooth rather than WiFi and Apple computers have Bluetooth built in. It works just fine on Android tablets. There are no issues with having both the trackpad and the Bluetooth keyboard connected and being used simultaneously. The trackpad is quite large, about three inches square, so there's plenty of room to maneuver.

▶ Charging

Charging your various devices used to be pretty inconvenient. All had their own proprietary charging connector so you had to carry multiple cables with you when you traveled and each had a bulky wall charger on one end. Manufacturers are getting smarter, however. Since these devices connect to a traditional laptop or desktop computer via USB and can be charged via USB, many of them now have a wall charger with a USB port. You connect the cable to the USB port and plug it into the wall. This means you an carry a single wall port and cut down on weight and bulk. You may also have multiple devices that charge via microUSB, meaning that you may be able to cut down on the number of cables you need to carry. I have one device, a Patriot Gauntlet WiFi hard drive (discussed more below) that uses the same high-speed USB connection as my D800 camera, so I can carry a single cable to use for both.

All of the cables and wall ports are fine when you are in a position to plug everything into the wall. That is not always an option though. Sometimes you are not near a wall plug or you're in the middle of doing something and you're running out of juice. What then?

In the last few years, portable battery packs have begun to be available to give you the ability to recharge or continue using your tablets and phones without the need for a wall plug. The technology has advanced to the point where these battery packs are

quite small and lightweight. Mophie and Veho are two makers of such battery packs. The one I settled on is from a company called Powerstick (**image 2.4**). It's a Canadian company so, you know, I like to support the local economy. Their PowerTrip charger has a high battery capacity. I've found I can get about $1\frac{1}{2}$ to 2 full charges of my phone and around a 60 percent charge on my 10-inch tablet from a single charge of the PowerTrip. It can be plugged into the wall or recharged via USB. It even has a solar panel so it can be charged in sunlight. Pretty slick! What really separates the PowerTrip from the competition is that it can be configured with anywhere from 4GB to 16GB of storage, providing you with an additional source of data back up when on the road.

▶ Storage

As I noted earlier, I do not consider the internal storage of my tablet to be "primary" storage. For one thing, it is too small to store significant amounts of data. Even tablets with microSD slots aren't sufficient for primary storage. At this point, microSD technology is only capable of 64GB in size, which is not a lot. It can also be frustrating to navigate through the various folder hierarchies to find what you are looking for sometimes. The internal storage is fine for things like documents or photos you take with the tablet or phone. But for more important data and larger volumes of data, external storage is vital. The internal storage or a microSD card can also be useful for temporary storage while editing images, as I will discuss later in the book.

USB-connected storage can work. The biggest problem may be where your OTG USB adapter plugs in. On my 10-inch tablet, it plugs into the charging port. When the adapter is plugged in, I cannot use the tablet in normal orientation propped up in a case. I either have to lay it down flat or flip it upside down. The screen will rotate, of course. While this certainly

can work, it can also be problematic if, for instance, you need to have a device such as a card reader in the USB adapter and still want to access external storage. This will be the case when, for example, you are transferring images from the memory card to the external storage after shooting. You will have the card reader plugged into the USB adapter, which means there's no place for a USB hard drive to plug in.

This is where the new class of WiFi hard drives comes in. There are only a couple on the market at the moment that provide significant amounts of storage. Seagate offers one that comes with either 500GB or 1TB of storage. Patriot Memory also offers one that comes as an enclosure only that will accommodate 2.5-inch standard or solid-state drives up to 2TB. It can also be bought with a 320GB hard drive pre-installed. The cost of the enclosure is about $100; with the 320GB hard drive installed, the cost is $150.

I have the Patriot Gauntlet (**image 2.5**) with the 320GB. That will hold ten 32GB memory cards. A 32GB card will hold roughly 400 full-sized RAW images from a Nikon D800 (36MP) and about 1,200 full-sized RAW images from a Nikon D700 (12MP), so the Gauntlet will hold 4,000 D800 images or 12,000 D700 images. That's a lot of images. I also have the Seagate Wireless Plus with a 1TB drive, which costs about $200.

When I am traveling or away from the office for personal shooting, I'm comfortable taking just a single external hard drive. Shooting for a client, I would carry two for added security. The size of the drives would be determined by how long I may be away and how much I'd expect to shoot. A 2TB drive will hold about 6 times as many images as the 320GB drive.

I will discuss using the drive—transferring images to and from it—in conjunction with editing in chapter

Image 2.5 ▶ Gauntlet WiFi hard drive.

5. One thing to note with these wireless drives is, if the battery charge is low, the WiFi connection may be weak. Keep the drives charged so that you have a full battery before heading out.

The Cloud is getting a lot of attention as more companies try to migrate users to the cloud, particularly for desktop software. Adobe has become embroiled in a firestorm of controversy since its decision to push users to a cloud-like model for its software. Cloud storage is another possibility for data warehousing, but it needs to be considered with care. For one, you are entrusting your data to an entity you don't know. The company could be out of business tomorrow and when you try to log in you find your data has disappeared into the ether. Cloud storage providers typically offer you a small amount of capacity for free then start to charge when you exceed that threshold. Pricing for cloud storage can be quite expensive as you use it incrementally more. For these reasons, the Cloud should, I feel, be used only as a temporary or secondary warehouse of data and only in small amounts. Options like Dropbox are simple to use. Many device makers are now offering cloud storage to their clients as well. You create your account and download the desktop version of the app. You are then able to move files to the Cloud, and those files will be accessible on your phone or tablet anywhere you have an Internet connection.

Cloud storage is another possibility for data warehousing, but it needs to be considered with care.

▶ Support

Support? What do I mean by support? What I am referring to are tools that can hold your phone or tablet in place so you don't have to carry or hold it. These tools can be fastened to the leg of a tripod or onto the rails of a video rig.

Unlike some of the other accessories we have looked at, choice in this particular area is not that wide at this point. There are numerous support mechanisms for tablets and phones, but most of these are intended for use with flat surfaces. They use a stick-on or suction-cup adhesive or they use a clamp with flat surfaces. None of those will work on a round surface.

There are a few out there that have developed clamps suitable for attaching a support mechanism to a tripod or rig. I have looked at most of them and have chosen two. The RAM Universal X-Mount from RAM Mounting Systems is one. The other is the Unite C-Clamp Mount from Joy Factory.

Universal X-Mount. Of the two, the X-Mount from RAM is my personal favorite. It comes in three sizes, one for phones, one for mid-size tablets (e.g., 7 inches), and one for full-size tablets (e.g., 10 inches). The mounts are made of high-quality polycarbonate plastic and metal. The arms that hold the device in place are spring-loaded; you squeeze them to open, insert the device, then release to close and grip the phone or tablet. The yoke clamp option easily fastens around the leg of a tripod and will close down small enough to clamp onto the standard 15mm rails of video rigs to enable the use of a tablet as an external monitor for shooting video. You adjust the positioning of the mount via the two ball joints on the arm. Both ball joints are loosened and fastened with a single tension adjustment knob. The arms of the mount also have soft rubber nibs that protect the device from scratches as well as improving grip on the device.

Unite C-Clamp. While I personally prefer the X-Mount, that does not mean the Unite is a slouch by any measure. One really nice feature of the Unite is that it is able to hold both mid-size and full-size tablets by adjusting the position of the arms on the sides of the holder. Unfortunately, it may not be suited for all mid-size tablets. At just over 4.5 inches in height, the second-generation Google Nexus 7 does not fit. The 7-inch Samsung Galaxy Tab 2, at 4.8 inches, should fit, as should the original Nexus 7 at 4.7 inches. The company includes self-adhesive rubber covers for the metal arms to improve grip and prevent damage to the tablet.

The arm of the unit is made of carbon fiber, so it is strong and lightweight. It adjusts via two ball sockets like the X-Mount; however, each ball socket has a separate tension adjustment knob. Positioning the holder takes a bit longer as a result. The backplate of the Unite is designed such that using the camera on a 7-inch tablet will not be possible, but it should be usable with 10-inch versions.

Both are very good products that have served me well since getting them.

▶ Productivity Apps

You are not likely going to use your tablet or phone just for photography tasks. You are going to want to surf the Web, read and write email, read e-books, maybe have access to a word processor and spreadsheet program. There are many apps available for all of these tasks, some free and some not. It can be difficult, sometimes, to cull through the selection to really find the winners. I know I like free—I like it a lot!—and if I can find something for free that works as I need it to, then I've won. Sometimes we have to pay the piper though. The good thing is that most apps are pretty inexpensive, at least relative to full software products like Microsoft Office or Photoshop. You are generally talking anywhere from $1 to about $5 for most paid apps, although you can pay more than that for a few. The most I have paid for an app is $14.

Fear not in deciding what apps to use. I have done a fair bit of research of both paid and free options and have found some good ones. My list isn't exhaustive, but it is pretty comprehensive and I have tried at least three or four in each of the categories discussed below.

Business. *Office Productivity.* When it comes to traditional office productivity on a tablet, one of the best options is also free. It is called Kingsoft Office. It has most of the functionality of a full desktop suite like Microsoft Office or OpenOffice. The user interface is well laid out too. You can work with spreadsheets, documents, or presentations, and it can save these files in the Microsoft formats for ease of sharing with others (**images 2.6–2.8**).

Image 2.6 ▲ Kingsoft Office menu bar.

Image 2.7 ▲ Kingsoft Office menu bar, continued.

Image 2.8 ▲ Kingsoft Office New Document screen.

In addition to Kingsoft Office, there are a few others you may want to consider. QuickOffice Pro and OfficeSuite Pro are both about $15 and offer similar functionality and well-laid-out user interfaces. One that has been around a lot longer, also $15, is Documents to Go Full Version (there is a stripped-down

Image 2.9 ▲ SignNow menu options.

Image 2.10 ▲ SignNow document list.

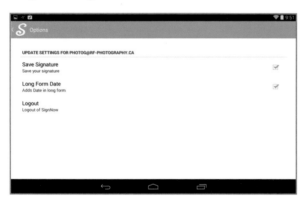

Image 2.11 ▲ SignNow setup screen.

free version). Documents to Go is showing its age. The user interface isn't as nice, and the functionality is lacking quite a bit compared to the others. OfficeSuite Pro offers a two-week trial so you can try before you buy. This is a rarity in mobile apps. Generally, once you buy you are committed. Many apps have free versions that are somewhat feature-stripped but still give

you a good idea of the user interface and functionality before you spend your hard-earned cash.

One thing you may need to be careful about is version compatibility. I have had newer Microsoft documents with the "x" (e.g., docx, xlsx) suffix that I have had difficulty opening with some of these mobile apps. If you have been sent a document from someone and cannot open it, you may need to go back and ask them to save it in a previous version so that you can open it on the mobile device.

Contract Management. Working photographers have the need to enter into contracts with clients. For several years, contracts sent back and forth via fax have been the norm. Today, in the Cloud environment, we can send contracts back and forth via the Cloud and execute those contracts using mobile apps.

There are several apps available for signing documents. The one I have settled on, for its ease of use and the fact that you do not need to use the developer's servers if you do not want to, is SignNow (**images 2.9–2.11**).

SignNow allows you to import documents from your device or from an email. It allows you to send and download documents to and from the Cloud via, for example, Dropbox.

The app developer indicates that .doc, .rtf, and PDF documents are able to be imported into the app. You can import documents directly from within SignNow. You are also able to open .doc and .rtf documents into the app by using the File Manager. File Manager apps are discussed later in this chapter. Locate the desired file in the File Manager app, tap it, and a list of apps to use with the document will pop up. Tap SignNow and the document will open in the SignNow app.

With a document open in SignNow, tap the screen to activate the menu bar. The available buttons are self-explanatory. Adding a signature to a document can be done with a finger or a stylus. Text or Date options bring up the virtual keyboard.

When one of these is added to the document, the app places the signature or text randomly on the page.

By long-pressing, you can make the text moveable and position it whereever you want it. Pinch allows you to make the inserted signature or text larger or smaller.

When you are finished, tap the checkmark and you will be asked to save the document. It is saved to the Documents folder in the app and is available on any device you have SignNow installed on.

In the Documents folder, tapping on the menu icon at the bottom of the document opens a menu that allows you to email the document to someone, create a template of it, archive it, delete it, and export it. It also tells you who has signed it. The Export command is the option to upload the file to the Cloud. Selecting Dropbox will bring up all the folders you have access to in your Dropbox account. You are then able to add the document to an existing folder or create a new folder and share that folder with another user.

SignNow makes managing contracts and getting signatures simple and easy. You can create template documents, store them in the Templates folder, then simply fill in the necessary fields when needed. Your standard form contract can be stored as a template, and when you meet a new client for the first time, you can fill in the client-specific information and both sign the contract on the spot, then email the client a copy or put it in a shared Dropbox folder. In the event the contract needs to be edited, you can open it in Kingsoft Office, make the edits, and save it as a new file ready for signing in a matter of minutes. My recommendation would be to keep a .doc copy of the the contract on your device in a separate location so that edits can be made easily, then save that as a new PDF, which you can import into SignNow.

Weather. Weather is an important thing to know for photographers but also generally. All jokes about weather forecasting aside, you can typically get a good sense a couple days out, which is about as far as I'd look at a weather forecast for any accuracy anyway.

I have found the AccuWeather app (**images 2.12 and 2.13**) to be quite good in terms of the information it provides and the accuracy of its forecasts. AccuWeather is the default weather app installed on all the Android devices I have seen. I have also tried The Weather Channel app, Weather Bug and, being Canadian, The Weather Network app. I like the depth of information from AccuWeather and prefer the layout of their user interface. The app can be configured to use the GPS chip in your phone or tablet to automatically update your location. The same is true for The Weather Channel and Weather Bug. The Weather Network requires you to input your location manually. In terms of accuracy of forecasts, The Weather Channel is close to AccuWeather, but Weather Bug and The Weather Network don't seem to be as good. Support for non-Canadian locations by The Weather Network is not as robust either. The one thing The Weather Network has that the others don't is a pollen report, which is useful for allergy sufferers (raised hand).

Image 2.12 ▲ Accuweather.

Image 2.13 ▲ Accuweather.

Reading. Reading is a task a lot of people are doing on a tablet. Electronic book sales have exploded in the last year and the trend will likely continue.

The Kindle app from Amazon.com is a must if you're going to buy and read e-books in the Kindle format. For reading of other electronic book formats, Bluefire Reader is simple and works well. Bluefire offers access to several online bookstores and has a great selection of public domain books for free, mostly classics. For those who prefer Barnes & Noble or Kobo, there are apps for those available in the Play store too.

Setting up your accounts on some of these apps is not at all intuitive and can be very tedious.

The Bluefire app allows you to adjust the color of the backlight. The Kindle app does too, but it only gives you three choices. With Bluefire, it is completely customizable. I was preparing for a trip to do some astrophotography in September of 2013 and, knowing I was going to be up through the night, I took my Nexus 7 to read some books. I was able to adjust the backlight to use a red color so that I didn't degrade my night vision. Other reading apps may also allow you to adjust the background color. Obviously, this only works for e-books that aren't tied to a specific retailer (e.g., the Kindle format, which requires the Kindle reader). Some Kindle books can be converted to be used with other readers, but many Kindle books have Digital Rights Management locks so you cannot convert those.

Social Media. Dedicated apps exist for all the major social media outlets in the Play store. The other alternative is to simply use your browser of choice to access the various social networks.

The Facebook app is quite good. It is simple to navigate and gives you access to your personal profile as well as any professional pages you may use. An accessory app called Pages Manager will give you direct access to your professional pages as well as

provide you with notifications in the status bar of the device when there is activity on your page. The main Facebook app doesn't do this.

The Google Plus app is, frankly, a mess. It is confusing, difficult to navigate, and frustrating to use. Using your web browser to access your Google Plus account is a better option, although the Google Plus mobile experience is not that good in either place. But let's be honest, Google Plus isn't all that spiffy either.

LinkedIn is best accessed via a browser, in my opinion. The mobile app is just okay. It works, but it is missing some of the functionality of the browser version.

The Twitter app is fine. It is nothing to write home about, but it works. If you manage multiple Twitter accounts, it is not so good, as you have to sign out of one and sign back in as another. In this case, an app that allows you to manage more than one account is preferable.

Tweetdeck, Hootsuite, and Seesmic all allow you to access and manage your Facebook and Twitter accounts from a single interface. Some have feeds for other accounts, such as LinkedIn or Google Plus, but are not universal in this regard. All have similar functionality within different user interfaces. It is going to be a matter of personal preference which you decide to work with. Setting up your accounts on some of these apps is not at all intuitive and can be very tedious.

Tweetdeck uses a sliding column setup for your various feeds. The problem is it is not overly obvious what column applies to what social media network, and some appear to be mixed. Setting up accounts in Tweetdeck is not the simplest of tasks, and development of the mobile app doesn't appear to have kept pace with the desktop app, which is much more user friendly. Tweetdeck also works in a browser, and I have found the browser-based to be better on a mobile device. The browser version of Tweetdeck, which is just for Twitter, is quite good.

Hootsuite works on a tabbed approach. You add your main accounts then determine what tabs you

want to add for each account (for example, Home Feed, Mentions, Retweets, and so forth). Setting up your accounts on Hootsuite is simpler and a much less frustrating experience.

Seesmic is fairly easy to set up and work with. Managing pages on Facebook isn't as easy and it is not possible to post to your page as your page ID; you'll be posting as your personal profile. Personally, if I am posting to one of the Facebook pages I manage, I want to post as the identity of the page, not my personal profile. For this reason, Seesmic isn't optimal.

Data Transfer. Transferring data to and from your device is, obviously, important. There are a number of ways it can be done. I will cover a few ways now, then later in the book when we are talking about an image organizing and editing workflow, a couple of others will be looked at.

The simplest way is just to plug your device into your computer via a USB cable. The device will show up as an external drive, and you can simply drag and

drop items to and from. The upside is that USB transfer is fast. Not many devices are USB 3.0 compliant, but USB 2.0 is still pretty fast.

Another way, if you are in a situation where your USB cable isn't handy or you are not in a position to use the USB cable, is to transfer data wirelessly. There are many apps available in the Play Store for WiFi data transfer. Most are free and they all work much the same way. The free versions are often ad-supported. There's really no need to pay for an app like this, with one exception: Some manufacturers limit the size of the files you can transfer with the free app. Look for one that has no such restriction. Depending on the manufacturer of the device, you may have a manufacturer-branded app for this purpose as well. Samsung, for example, provides its Kies app, which can be used to, among other things, transfer data wirelessly.

The majority of these apps are browser-based (**images 2.14–2.17**). You open the app on your device and are instructed to type an IP address into

Image 2.14 ▲ WiFi File Transfer launch screen.

Image 2.15 ▲ WiFi File Transfer preferences.

Image 2.16 ▲ WiFi File Transfer connection confirmation.

Image 2.17 ▲ WiFi File Transfer PC desktop screen.

the address bar of your browser. The storage and file structure of the device can then be accessed through the browser, and you can transfer data to and from each place. It is also possible to use these apps to do device-to-device data transfers. Both devices will need to be connected to the same wireless network.

You may also want to transfer data from one device to another. I did this after I had to send my phone in for repair and the data on it got wiped out. Backing up a cell phone and tablet is not a big priority because there are not the same kinds of programs with user settings and customizations as on a desktop or laptop computer. There is not nearly as much data on these devices either and the data is, for the most part, not original but rather copies of data that is warehoused elsewhere. Where backing up is important is for data, such as documents, you may create, update, or amend on the device. Your apps don't need to be backed up because you can always download those again from the Play Store. The exception may be for something like a game where you want to back up the app data so your game history, high scores, and the like do not get wiped out. This can be done using the backup feature of the device, which will back up the data to the Cloud on Google servers. I do not recommend using a smartphone or tablet as primary storage. Mobile means transient. If you create or change important data on the device, make sure you move it to your desktop or laptop so that it can get backed up in your usual backup routine. You do have a backup routine, right? Right?

Back to transferring data between devices. Moving data between devices is not a simple task. While the browser-based apps will work, there can be limitations as noted above, and moving multiple files can be tedious. At this point, WiFi Direct is not an option on all devices; it can be difficult to set up and it doesn't work really well yet. SuperBeam is the app I found that works well and is simple to use (**images 2.18–2.21**). Using it, I was easily able to transfer data from my tablet to my repaired phone so as to set up my image portfolios again. SuperBeam transfers everything into a single SuperBeam folder. From there, you can select files and move them to another folder location with a few easy touch commands. There are other device-to-device transfer apps available—I have just found SuperBeam the easiest to use. Both devices need to be connected to the same WiFi network to use these types of apps.

Image 2.18 ▲ SuperBeam home screen.

Image 2.19 ▲ SuperBeam settings.

Image 2.20 ▲ SuperBeam settings.

Image 2.21 ▲ SuperBeam settings.

Image 2.22 ▲ File Manager HD.

▶ File Explorer/File Manager

Some devices come with a file explorer or manager pre-installed. These act like the Windows Explorer and allow you to see the entire file structure of your device. This is a fast and handy way to move data around on the device (for example, as above, when moving files from the main SuperBeam folder to other folders).

There are a large number of these types of apps available on the Play Store. Many are free. Unless you do not want to see advertisements at the bottom of the page, there really is no reason to pay for one. There are no limitations on file sizes, as you're simply moving around data that already exists on the device. Some, such as ES3 File Explorer File Manager, provide additional functionality but are more confusing to use. The KISS principle works here. The simple File Manager or File Manager HD (**image 2.22**), which is designed for higher-resolution screens, do the job quite well and are simple to use.

▶ Navigation

Google Maps. One of the things that Google is well-known for is its mapping service. Google Maps (**images 2.23–2.28**) is great for getting directions to a place and finding where restaurants, shops, parking, and more are around where you are. It can also be used for turn-by-turn directions. More recently, the Maps app has been modified to allow you to use it offline. That is, you can set up a route while connected, then save the map onto the hard drive of your device to be used while you're driving, like a GPS device. This is a terrific update to the Maps app. Maps comes pre-installed on Android devices.

Image 2.23 ▲ Google Maps.

Image 2.24 ▲ Google Maps Find Place.

Image 2.25 ▲ Google Maps Route Creation.

Image 2.26 ▲ Google Maps Route options.

Image 2.27 ▲ Google Maps Directions.

Image 2.28 ▲ Google Maps Directions, cont'd.

Image 2.29 ▲ Field Compass.

Image 2.30 ▲ Field Compass settings.

Image 2.31 ▲ Field Compass settings, cont'd.

Image 2.32 ▲ Field Compass Night Mode.

Compass. Yes, a compass. Even with utilities like Google Maps, having a compass is still a good idea. Particularly when you're off the road and on a trail. It's very handy, for example, if you're doing astrophotography and want to make sure your camera is pointed north.

I have tried several, but the one that I settled on is Field Compass (**images 2.29–2.31**). It comes in two versions. Field Compass Holo, which is free and ad-supported, and Field Compass Plus, which is a paid version with no ads and a few additional features. One of those additional features is the paid app will set your declination automatically using the GPS chip in the phone or tablet. Declination is your position relative to magnetic north. It changes based on your location on the planet. Compasses point to magnetic north. Maps and directions use true north, which is the line to the North Pole. Knowing your declination, you can compensate for the variance and make sure you are pointing or moving in the right direction. Field Compass is good in that you can set it to use either true north or magnetic north. By setting the declination automatically, the adjustment between true and magnetic north is made on the fly. If you have to set it manually, your reading and heading could be off. The other big benefit of Field Compass is that it has a Night Mode (**image 2.32**). In this mode, the entire screen turns different shades of red. Red does not affect night vision, as mentioned earlier, so you can use the compass in the dark, as when setting up for star photography, and not have to worry about your eyes having to readjust to the darkness afterward.

GPS. The discussion of GPS apps could go either in productivity or navigation. GPS stands for Global Positioning System—a series of satellites that aid in navigation by providing locational information to travelers. GPS use has become so ubiquitous on boats and ships that many lighthouses have been rendered obsolete. Google Maps and other navigational tools use GPS to track your route and provide turn-by-turn directions.

There is another use for GPS data; however, it can be used to geotag digital photos. Geotagging is discussed in more detail in chapter 5. There are several apps available on the Play Store, and some are better than others. The strength of the GPS receiver in your phone or tablet will also determine how well these apps work.

I have tried many of the ones available. I find that many do a decent job but not a great job. The biggest

issue is missing data points. Not just a few, but entire sections of a route. There is one that stands above the rest in the group. That is GPS Logger for Android (**image 2.33**). It is a free app and works very well for me. You will likely need to try a few on your device(s) to see which works best for you.

You will use the app to create a tracklog, which contains locational information. Each of the data points on the log is time-coded. You will use the tracklog later to sync the locational information to the image metadata based on a best match of the time stamp in your image files to the time stamp of the data points (**images 2.34–2.39**).

Image 2.33 ▲ GPS Logger start screen.

Image 2.34 ▲ GPS Logger preferences.

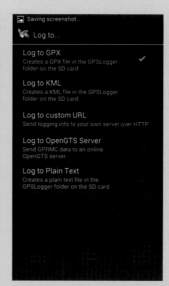

Image 2.35 ▲ GPS Logger preferences.

Image 2.36 ▲ GPS Logger preferences.

Image 2.37 ▲ GPS Logger preferences.

Image 2.38 ▲ GPS Logger preferences, distance between track points.

Image 2.39 ▲ GPS Logger preferences, time between track points. (Personally, I use a time of 10 seconds and find it works well.)

3. The Mobile Portfolio

We all know how good photographs can look when displayed on a computer screen. The backlighting makes them pop like a print simply cannot. A well-made print is still a beautiful piece of art, but even the best prints just don't have the same "life" as a backlit image. There are times when a printed portfolio is still called for. There are many situations where a client is happy to see a digital portfolio, however. Having a digital portfolio on your phone or tablet makes it a very simple matter to show your work to someone you may meet at a function or event. You never know who may end up being a potential client.

The screens on phones and tablets are amazing; they are high-quality, high-resolution displays that, in many cases, offer full high-definition resolution and can make our flat, two-dimensional images almost look 3D. These screens are very sharp owing to the pixel density—far sharper than the computer screens we use for editing. That much higher pixel density means we have to process the images a bit differently to prepare them for viewing on a phone or tablet.

The other aspect of a digital portfolio that makes the format work well is that you can easily have multiple portfolios for different purposes at your fingertips at all times. Updating the portfolios with new work is also a simple process.

When putting together a portfolio of your work to show to others, you want to show your best work. That may seem obvious to many, but it is true. Show only your best work. That also means you may not be the best one to decide all of what goes in. We get attached to certain images because we like them or because of the experience we had in capturing them. That doesn't mean those images necessarily represent our best work. It may be worthwhile having someone whose judgment you trust, who knows photography and art, to help in determining what goes

Image 3.1 ◄ Headlight on a rusted out Chevy. Shot on film with a Canon EOS Elan II.

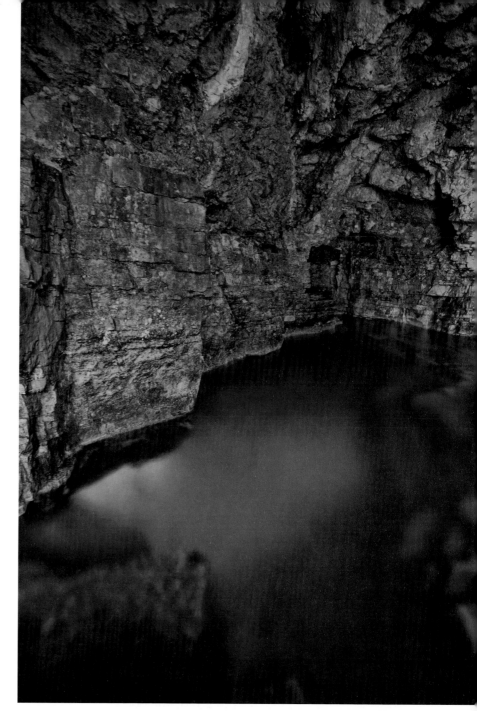

Image 3.2 ▶ The Grotto at Bruce Peninsula National Park, Tobermory, ON. The lighter area of the water is an underwater tunnel that goes from the grotto out into Georgian Bay. Seven-shot HDR bracket, merged in Photomatix, shot on a Canon 5D.

in. Most of the time you are going to be right. The odd time, though, that second, objective set of eyes is going to be helpful.

In addition to your best pure photography, you want to show your best editing. If there is a particular aspect of your editing work that you feel you are better at than others, make sure to include it. If there is a type of correction you make, that not all other photographers do, be sure to include samples of it. Here's an example. In shooting architectural interiors, you are often faced with mixed lighting. You can have daylight streaming in windows which may be around 5000K, or cooler, and the room may be lit with tungsten light that is very warm, at around 2500K. You can set your camera white balance to one or the other. That will lead to areas of the shot that are properly color-balanced for the light and areas that appear too warm. Some photographers will correct for that, either at the time of shooting by evening out the light sources (replacing lightbulbs or putting gel filters on the windows) or in editing. Some will not correct for it at all. If you do, including an image or two with a before-and-after comparison in your portfolio can help set you apart from other photographers. You can also show the breadth of your capabil-ities. Different types of photography require different editing skills. Softening skin in a portrait is a different skill from compositing images for an advertisement.

For each type of work you want to showcase, create a different digital portfolio. Put your commercial work in one, your editing work in another, your portrait work in another. You can even split up your

professional and environmental portraiture from your family and studio portraiture. If you shoot glamour or boudoir, those too should be separated from your family portraiture. Black & white should be separated from color. Don't worry if there is some overlap. Not everyone is going to be looking at all your portfolios, so they won't necessarily see all the overlap, and some overlap is expected because, for example, you may have some of the same images in both black & white and color.

Create a title page for your portfolios. These should be an introductory page with your name and the

Image 3.3 ▲ Resize in Photoshop.

Image 3.4 ▲ Resize in Photoshop.

portfolio title as well as a few of the images from that portfolio.

When preparing images for display on the tablet or phone, there are a few things you want to do to optimize the viewing experience.

▶ Resizing Images

Tablet and phone displays have moved to high-definition resolution and in some cases beyond. The Google Nexus 10, for example, has a 2560x1600 pixel resolution. Many other tablets offer Full HD (FHD) resolution of 1920x1200 and others are lower, at 1280 pixels on the long side. Samsung's Galaxy Tab 10.1 has a screen resolution of 1280x800 pixels. Still impressive for such a small display.

For those tablets that have 1920 or 1280 pixels on the long side, you can comfortably size your images to 1920 on the long side. These will display well on devices offering both resolutions. You will be able to zoom in on both and still retain high quality. If your device has a higher resolution than FHD, size your images to be the same pixel dimension on the long side as the resolution of the display. In the case of the Nexus 10, then, you would size your images to be 2560 pixels on the long side.

Let the short side of the image fall to what it will based on the long side dimension. Don't bother to crop the images into the exact aspect ratio of the screen you will be displaying on. You have already cropped your image to make it look best in the earlier stages of editing. Recropping to meet a specific display dimension could make the photo look less than optimal.

Resizing in Photoshop. You have finished all your editing and are now ready to prep the image for display on your device. The first step in that process is resizing. To resize an image in Photoshop, go to the Image menu and select Image Size (**image 3.3**). In PS CC, you will be presented with a dialog box that looks like the one in **image 3.4**. In earlier versions of Photoshop, the dialog box will look a bit different.

In either case, you want to make sure that you have Constrain Proportions turned on. In PS CC, you

Image 3.5 ▶ Resize in Lightroom.

know this when you see the line connecting the Width and Height dimensions. If these dimensions are not in pixels, change the setting in the dropdown menu.

Input the proper dimension for the long edge of the image. With the proportions constrained, the short side will automatically adjust. You want to have Resample checked. In terms of what resampling method to use, in most cases, using Automatic will choose Bicubic Sharper. This does add a bit of sharpening to the image. Given that sharpening may be an issue with some devices due to the screen pixel density, you are probably better off selecting Bicubic. Bicubic does not apply any additional sharpening, allowing you more freedom to adjust the sharpening as needed for the device. Click OK and you're done.

Resizing in Lightroom. Lightroom does a lot of the image finalization steps in the Export process. Export is the process where you create your TIFF or JPEG version after editing.

When you open the Export dialog box via File > Export (**image 3.5**), you will be presented with the various options available for saving the image.

Resizing is done, not surprisingly, in the Image Sizing section. Check the Resize to Fit box and select Long Edge from the dropdown menu. Input the desired dimension of the longest edge in the dimension box and choose Pixels from the dropdown. Since we are downsizing images here, you can leave Don't Enlarge unchecked or have it checked, it doesn't matter. The resolution figure is equally unimportant because when displaying images on a screen, only the pixel dimensions matter. The image will not appear larger or smaller based on the pixel resolution.

▶ Color and Color Management

While it is true that tablets and phones now have really high-quality screens, for the most part, and can display rich color, you still have to keep in mind you are working in a non-color-managed and uncalibrated environment. This isn't necessarily a bad thing. The displays of the good devices are quite accurate right out of the box, so color accuracy is not going to be a big concern. It is breadth of color that is the biggest issue.

Color Management Essentials. The topic of color management is one that takes up entire books. Many entire books. As such, it simply is not possible to go into a lengthy and involved discussion of color management in this book. I can give you an overview, however.

Color management is the process whereby we get all of the tools in our digital darkroom workflow speaking the same language. The language is color. The problem is, without our intervention, the various tools and components we use will speak different dialects of the language of color. That is, each device will interpret the same color numbers such as Red-82, Green-119, and Blue-195 differently and render those color numbers differently. Mid-tone steel blue will look different on your computer monitor from how

it looks on a print. If we allowed that to happen, we would never be able to know if we have a good print.

Color management to the rescue! Well, sort of. As much as we would like the process of color managing our digital workflow to be very precise and scientific, it is still something of a dark art.

The time between profile and calibration routines will decrease as the monitor ages.

Monitors. You want to ensure you are working in as controlled an environment as possible. That means you want to calibrate and profile your computer monitor(s) regularly. How regularly? It depends on the monitor and how much it is used. Older Cathode Ray Tube (CRT) monitors need to be reprofiled more often. The time between profile and calibration routines will decrease as the monitor ages. If the monitor is used a lot, then after a couple of years you may need to profile and calibrate every other day. It will get to a point where it needs to be done every day. With the newer LCD monitors, you can get away with a slightly less rigorous routine. Generally, I wouldn't want to go more than one month. You do want to use a good hardware colorimeter or spectrophotometer for this process. Make sure you understand the software that your measurement device uses so you are not inadvertently missing information or inputting the wrong information or skipping steps through the process.

Gamma and Color Temperature. Much discussion takes place on these two variables in the monitor profiling process. Is a gamma of 1.8 or 2.2 better? Do I use a monitor color temperature of 5000K/D50 or 6500K/D65?

When it comes to gamma, a standard has developed around the 2.2 number. Users of Mac computers used to be recommended to use 1.8, but that has changed. The 2.2 figure is the standard today.

Color temperature is more fluid. There is no hard-and-fast, must-use-at-all-costs number. The goal of the process is to generate the best-possible match between what you see in a print and what you see on your computer screen for the given viewing environment. Those last five words are the key: *for the given viewing environment.*

You will never get a perfect match between your monitor and print. You can get very close, however. The light under which you evaluate your prints plays a big role here. A warmer light will mean you probably need a warmer monitor color temperature. Conversely, a cooler light means you may need a cooler monitor color temperature. If you use something that is close to 5000K/D50, then you can use the mythical 6500K as a *starting point* for the monitor color temperature. If you are getting the idea that this is a trial-and-error process, are right. You may need to reprofile several times to get the best match to a print. You do want to evaluate your profile by comparing it to a well-made print.

Printing. When we talk about the process of color management as it relates to printing, what we mean is that we are using a paper that has been profiled, that the profile is accurate, that we use the profile in the printing process, and that we allow Photoshop, or whatever color-managed image-editing application you use, to control the printer and the printing process rather than the printer and its own driver software.

Manufacturers of high-quality printing media generally provide printer profiles for several of the top-quality printers and make these profiles available for download from their websites. These profiles are typically very good. If you are not getting a good monitor-to-print comparison, first look to your workflow to make sure it is solid. Next, look at the profile. Print a couple other images using the profile to see if the problem continues. If it does, contact the paper manufacturer to see what help they can provide. If the problem continues, you may need a custom profile.

There are people who will make custom printing profiles. The process involves them sending you a test image with instructions on how to print it. You print the test image and mail it back to them. They will

then measure the image, create the profile, and send it to you via email or provide a download link. You can also create your own printing profiles with the right hardware and software. This is a process I would suggest is only a last resort. It can be a time-consuming and error-prone process, and the equipment to create good profiles is typically not inexpensive.

▶ Mobile Color Management

In short, it doesn't exist. At least not yet. The folks at Datacolor have created an app, Apple-only, that they claim allows you to have a color-managed environment on your iPad. The catch is it only works inside their companion gallery app. The other catch is, it really is not a color-managed environment.

Despite the inability to use good color-management practices on a tablet or phone, as I noted elsewhere, with the right device you can still have very good color reproduction. Perfect? No. As good as a desktop monitor? No, but still very good. Certainly better than most laptops. Whenever I traveled with a laptop and wanted to do some cursory editing before coming back to my office, perhaps to share something on the Web, I was always unsure of how it really looked. I had to wait until I got back to my desktop computer to really see what I had. Over time, I got accustomed to the vagaries of my laptops and could come up with something that was okay, but just *okay*. Now, with my tablet, I have a very high degree of confidence in what I am seeing on-screen and can be much more comfortable doing some initial preview editing and sharing some of those images on social media or with a client.

I do expect that we will reach a point where the mobile digital darkroom will be very much a part of our color-managed workflow. And I do not expect that time to be too far off in the future.

Just as you are used to doing for web display, you want to tag your images with the sRGB color profile. This will ensure the color displayed on your device is as accurate as possible.

Before loading large numbers of images onto the device, see how it renders color. Go to your website or your Flickr page and pull up some images on the device as well as on your calibrated computer screen in your color-managed setting. You do calibrate your monitor and you do practice good color-management techniques, right? Right? Compare the image on your computer screen to what you see on the tablet. How does the color look? Over- or undersaturated? About right? How about color temperature? Does the device look cooler or warmer than your computer display? Make note of these things. This will help you in preparing your images for display on the device. You may want or need to adjust the warmth or coolness of the images you intend to house on your phone or tablet so that the match is closer to your desktop monitor.

> . . . we will reach a point when the mobile digital darkroom will be very much a part of our color-managed workflow.

Converting Color Spaces. I want to make it clear that we are *converting* from one color space to another, not *assigning* a color space. These two operations have very different impacts on the look of an image. Converting from one color space to another will, for the most part, leave colors in the image unchanged. Converting simply remaps the color numbers so that the visual color representation is maintained. I did say "for the most part." Where you may see a slight change in the visual representation of the image is in highly saturated colors or colors that do not fit into a different color space. In those cases, you will see a slight change in the look of the image. Assigning a different color space is entirely different. When you assign a color space to an image, you change the visual color of an image because the color numbers are not remapped. Values of R200, G120, and B75 will have a different visual appearance in a small color space like sRGB than in a large color space like ProPhotoRGB. We are converting in this case because we want the visuals of the image to remain the same as much as possible when viewed on a different device.

Image 3.6 ▲ Convert color space in Photoshop.

Image 3.7 ▲ Convert color space in Photoshop.

Image 3.8 ◄ Convert color space in Lightroom.

Converting in Photoshop. Converting from one color space to another in Photoshop is a simple process. With your image open, go to the Edit menu and select Convert to Profile (**image 3.6**). A dialog box will pop up. In the Destination Space dropdown, choose sRGB from the list and click OK. You can leave all of the other options at the defaults (**image 3.7**).

With the image converted to the desired color space, you can now proceed to the next step of output, sharpening, which is discussed next.

Converting in Lightroom. The process of converting to a different color space in Lightroom is done during the image export (saving) process at the same time as the resizing is done, as we saw in **image 3.6**.

Once you are finished editing an image, are ready to save it, and have the Export dialog box open, scroll to the File Settings area of the Export dialog. Here you will choose the file type and color space of the exported file. Select sRGB from the Color Space dropdown (**image 3.8**).

► Sharpening

Sharpening is the one aspect of the image-editing process that you are likely to have to change the most from your normal workflow.

If you're up to date on sharpening philosophy, you know that the current thinking is that sharpening is best done in a three-stage process: capture sharpening, creative sharpening, and output sharpening.

Most digital cameras impart a slight softness to a captured image. The reason for this is that the color filter array that sits on top of the sensor, the Bayer mosaic array, filters light in discrete blocks of red, green, and blue. When these discrete blocks are mixed to create the full range of color in our images, this demosaicing process blurs the image slightly. In addition, most cameras have an anti-aliasing filter on top of the sensor. This filter also imparts a bit of blur and its main purpose is to help avoid the "stairstep" pattern that can be created from the square pixels on lines that aren't perfectly horizontal or vertical.

Capture sharpening reverses the slight blurring imparted at the time of capture and by initial conversion in your RAW converter of choice. You are shooting RAW, right? Right? If you're shooting JPEG, then capture sharpening doesn't apply because the camera is already applying sharpening during the conversion to JPEG. Capture sharpening is applied to the entire image, and you need not make any changes to your capture sharpening for display on mobile devices.

The second stage of sharpening is creative sharpening. At this point, we have done much of the editing of the image and want to make some final enhancements. Unlike capture sharpening, creative sharpening may be applied to only parts of the image. That's the creative part. In general, it will be applied, or applied more, to areas of high-frequency data and will

RAW and JPEG

If you are reading this book, you are probably pretty serious about your photography. You probably also are well aware of, and have perhaps participated in, the many debates that have raged over the last number of years, and continue to rage in some places, about RAW vs. JPEG. It has become tedious.

This short discussion is not going to be about one vs. the other. It shouldn't be a one vs. the other issue. I am going to talk about RAW or JPEG because there are times when, even though you lose some things, shooting JPEG may be just fine.

RAW, obviously, is the generally preferred capture format. You know all the advantages. You have a great deal of flexibility in editing because nothing is "baked in." You can convert your RAW images into high-bit-depth TIFF files in wide color spaces that allow you to make big, beautiful prints. HDR photographers know that the increased quality of RAW files can make for a much better merging and tonemapping experience.

Yes, but . . . While I shoot RAW for most of what I shoot, there are times when I make the conscious choice to shoot JPEG. If I am in a situation where the quality and flexibility of RAW are not needed, I may shoot JPEG. Such a case may be if I am shooting just for distribution on the Web. There may be times when you are capturing large numbers of images and want to save some memory card space. Shooting for time-lapse would be an example of this. You will likely be downsizing the images to 1920x1080 or even 1280x720, so shooting RAW may not be necessary. Another situation where I may shoot JPEG is if I am shooting for a lower-quality output medium like a newspaper.

When I make a conscious decision to shoot JPEG, I do it with the full knowledge that I lose the flexibility that RAW provides. I do it in situations where I should not need the added flexibility of RAW—for example, when there is not an overly wide dynamic range, when I can nail the white balance at the time of shooting, or I won't need to do much post-capture editing.

So as you can see, it is not necessarily a one vs. the other argument. Rather, it is a one or the other question decision that you should make based on the needs of the end product and how much of the flexibility of RAW you need to have available to you. Even for HDR, shooting JPEG can be fine.

Make an informed choice for yourself about what format you need to shoot with in a given situation.

Image 3.9 ▼ This rusted metal is an example of high-frequency data.

Image 3.10 ▼ This soft, impressionistic multiple exposure of pansies is an example of low-frequency data.

be applied less or not at all to areas of low-frequency data. Why do I say data? Because that is what a digital image is. It's data. Areas in an image of high-frequency information are areas of strong detail—things like rust on metal, tree bark, and detailed woodwork on furniture (**image 3.9**). Low-frequency data is the opposite—a blue sky, areas of consistent, detail-less color, smooth surfaces, and soft, impressionistic images (**image 3.10**).

When it comes to creative sharpening, many people overdo that already. Be careful. You don't want your images taking on that "crunchy" appearance that can come from oversharpening. The telltale halos that you get in some images are also signs of too much sharpening. Those don't look good in a print nor on a computer screen, and they look even worse on a high-pixel-density mobile device. The key to creative sharpening is when it looks right, back off about 5 percent.

I am not going to discuss creative sharpening in this book. There are many different methods of creatively sharpening digital photos, and each of us has one or more methods that work for us already.

The last stage is output sharpening. At this stage, you are applying sharpening to the entire image, and the sharpening is specific to the type of output you are intending for the image. Printed images require different output sharpening than images for Web use. Matte and textured surface papers require different output sharpening from glossier papers.

When it comes to output sharpening for mobile devices, this is where you are going to differ most from your usual workflow.

To best see this, load a few images you have sharpened for a regular computer screen and Web use onto your mobile device. Take a look at them. I'm going to bet they look a bit oversharpened. That is because our computer screens do not have the pixel density of mobile devices. Think of it like a print. The more you enlarge an image in print, the softer it looks. Eventually, there isn't enough

Image 3.11 ▲ Output sharpening in Lightroom.

information and all you see is a murky, pixelated piece of paper. You've spread the available pixels out over too large an area.

Your 24 inches, or larger, desktop computer monitor may have a resolution the same as a Google Nexus 10 tablet, but it is spread over a much wider area. You are spreading the pixels out over a wider area, so the image will look softer and you need to sharpen it a bit more. The NEC PA241W is a 24-inch monitor with a resolution of 1920x1200. That's the same as my Asus tablet in a 10-inch display. The NEC has a pixel density of 94 pixels per inch. The 10-inch tablet has a pixel density of 224 pixels per inch. That is nearly two-and-a-half times the pixel density of the desktop monitor. It stands to reason that images will appear much sharper on the tablet. That is even more true of a smartphone with FHD resolution packed into a screen of 4.5 to 5 inches.

When it comes to mobile devices, you may not need to apply output sharpening at all. If you do, it will be less than what you need for traditional screens. It will take a bit of experimentation to get it right because it will depend somewhat on the device.

Output Sharpening in Lightroom. As a starting point, if you are using Lightroom to export your images for mobile display, try using Screen as the Sharpen For selection and Low as the amount. The output sharpening options are also a part of the Export process (**image 3.11**). You will find these under the Image Sizing section. There is very little choice here. You select the output type (Screen or Print) and then the degree of sharpening (Low, Medium, or High). The actual sharpening is fully automated from there. The output, as well as capture, sharpening in Lightroom is based on the methods from the Pixel Genius Photokit Sharpener plugin for Photoshop. These same algorithms are also included in Adobe Camera Raw.

Output Sharpening in Photoshop. If you are using Photoshop to do your output sharpening and using, for example, the High Pass sharpening method, start by reducing the amount of sharpening by 25%. You can do this by reducing the Radius of the High Pass filter and/or by reducing the Opacity of the High Pass filter layer. Try it on a few images, load them onto the device, see how they look, and make adjustments accordingly.

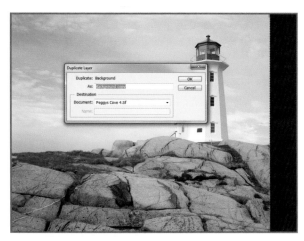

Image 3.12 ▲ Duplicate Layer in Photoshop.

Image 3.13 ▲ High Pass filter.

Image 3.14 ◄ High Pass filter radius.

Image 3.15 ◄ High Pass layer Blend Mode changed to Soft Light.

The High Pass Sharpening technique is one that has been used for many years. It works well and allows the photographer to sharpen more aggressively if needed without introducing the halos that the standard Unsharp Mask can produce.

To do High Pass sharpening, create a duplicate of your main image layer (Background) and make sure it is placed just above the Background layer (**image 3.12**). Rename it Output Sharpening or something similar that will remind you what it is for. Go to Filter > Other > High Pass (**image 3.13**) and input a Radius of 7 or 8. A Radius level of 10 is generally considered "standard" when using the High Pass method for creative sharpening (**image 3.14**). Click OK and watch your image turn ugly. Don't worry, we're going to fix it.

In the Layers palette, change the Blending Mode of the layer to Soft Light (**image 3.15**). Other options such as Hard Light or Overlay can also be used, but these are quite a bit more aggressive and the results may be undesirable. You can now adjust the degree of sharpening further by reducing the opacity of the High Pass layer.

It is also possible to put your output sharpening layer at the top of your image stack. Keep in mind that sharpening is, effectively, an exercise in increasing contrast in the image. If you have any other contrast adjustments such as Levels or Curves in other layers, by placing the High Pass layer above those, you will be further enhancing the effect of those layers. That may not be what you want. The degree of that additional enhancement will also change with the Blend Mode chosen. Soft Light may not show much of a difference, but Hard Light and Overlay will make an evident visual difference.

▶ File Ordering, Transfer to Device

Now that you have your images prepared for display on your Android devices, you need to organize them and get them ready for transfer.

In Lightroom you can use the Collections feature. Create a collection for each group or portfolio of images you want to transfer to the device. To get photos into a collection, you can drag and drop or you can right-click and select Add to Quick Collection. From

the Quick Collection, you can export the images directly to your hard drive or select them and drag them to the Collection you created previously.

To re-order images in the collection, simply drag the image to the position you want it in the collection. Ordering images is important. I cringe at the idea some people express that you want your portfolio to "tell a story." What you want to do is have continuity in the portfolio. Put all landscape orientation images together, then all portrait orientation images together. That way the viewer is not constantly rotating the device. They do it once as they view the images. Put all the images of a similar type together. If you do product and food photography, put all the products of the same type together and all the food images together. If you have interiors and exteriors as an architectural photographer, put those together respectively. To go back to the earlier example of proper white balance correction, put those images together back-to-back. Showing one then, ten images later, the other doesn't have much of an impact on the viewer, and the visual effect of the color balancing will be nil—the viewer will simply think you have a duplicate in the portfolio. That is something else to make sure of. Make sure you have not got duplicates. Even two images that are very similar and may be confused as duplicates should not be in the portfolio.

Adobe Bridge also has a Collections feature. It works much the same way as Lightroom. You create a collection then add images to it by dragging and dropping. There is no Quick Collection feature, however. Just as in Lightroom, you can re-order images by dragging them within the collection.

Once you have your images ordered as you want them, you can export to the hard drive in preparation for transfer to the device. Naming the files properly at the time of export is key to making sure they remain in the proper order once you have them on the device. Using a space or a dash (-) in the filename will not keep your files in the proper order. Naming conventions like Image 1 or Image-1 will mean that image 10 will follow image 1 and image 20 will follow image 2.

To keep the order you have set up on your computer, you need to name the images with a continuous filename using no spaces or other characters, for example Image01. You can set up the export from either Lightroom or Bridge to rename the files. If you start with the proper naming sequence, all the images that follow will be named in sequence and remain in the proper order when loaded onto the phone or tablet (Image01, Image02 . . .). I recommend exporting each collection or portfolio to its own folder on your hard drive. You can then easily transfer the entire folder of images to the device and the gallery apps will display them as separate collections.

Any of the methods covered in chapter 2 for transferring data to and from the mobile device will work to transfer the images.

▶ Presentation

Android devices come with a stock Gallery app. It is simple but not overly useful for our needs as photographers. The stock gallery app doesn't provide any way to customize views or albums, set up slideshows or exclude certain images or folders. Any photograph on the device will show up in the Gallery app. This can make the home screen of the app look jumbled and messy. You want a presentation method that will make your images look as good as possible and that is clean, only showing the images you want to show. There are three other gallery applications available that are far better than the stock version.

QuickPic. QuickPic (**images 3.16–3.22**) is free and has no ads nor usage limitations. It's a good step up from the stock gallery. It allows you to customize the view of the various portfolios and images in a grid form or list, gives you options for transitions and transition speed in slideshows, and allows you to alter the background color that your photos are viewed against.

Like the stock Gallery app, it shows more images than you may want to have showing, and while some can be excluded, not all can. As a result, there may be a couple more extraneous images or folders showing on the main screen of the app than you would like. It

Image 3.16 ▲ QuickPic home screen.

Image 3.17, 3.18 ▲ QuickPic settings.

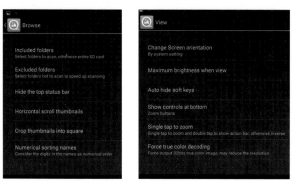

Image 3.19, 3.20 ▲ QuickPic settings.

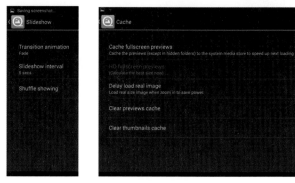

Image 3.21, 3.22 ▲ QuickPic settings.

allows you to exclude entire folders but not individual images. In order, for example, to exclude an image that is on the root folder, you would have to move the image into another folder first. Excluding the root folder would also exclude the folders that contain your image portfolios. The app also includes the ability to only include certain folders. You can use this feature to scan the specific folders only where your portfolios are stored. This is still a bit of a kludge, however, because if you want access to the entire file system again, you have to undo those inclusions and exclusions.

QuickPic is a good app and far better than the stock gallery app, but a couple others are better.

F-Stop Media Gallery. F-Stop Media Gallery comes in both free (ad-supported) and paid versions. Personally, I don't want ads at the bottom of the screen when people are viewing my images; opt for the paid version if you don't either.

F-Stop is much more robust than QuickPic. It provides you with a much greater ability to separate images into specific groupings and allows you to decide what screen the app opens on so you can just present your viewer with the images you want them to see (**image 3.23**). It also allows you to include or exclude specific folders, but given the other custom options, this feature isn't really necessary.

The app scans the device storage for media files when it first starts up. The Folders icon is where you will find the images you transferred from your computer in the respectively named folders. You can use the Folders page as the launch page for your portfolios, but the better option, I think, is the Albums page (**image 3.24**). Here in the Albums page only those images you put into albums will be visible, nothing else. This affords a clean starting point for your viewer.

To put images into an album, open a folder of images and long press on the first image. This will bring up a taskbar with new functions. Open the menu on the far right and scroll down to Select All. Open the menu again and select Add to Album. You'll have

the choice of adding the images to an existing or to a new album. Selecting new will then allow you to type in the name of the album. In the app settings under Main > Other > Startup screen (**image 3.27**), you can select Albums as the screen that appears upon launching the app. You still have access to the other screens by using the Back button on the device. F-Stop allows you to nest albums inside other albums as well. If you have a commercial master album then two or three, or more, different types of things you shoot commercially, you can separate those into sub-albums inside the master album. This makes organizing images quite effective.

The app costs about $5.50 in the Play Store.

Image 3.23 ▼ F-Stop organization tool.

Image 3.24 ▼ F-Stop Albums screen set as home screen.

Image 3.25 ▼ F-Stop viewing options.

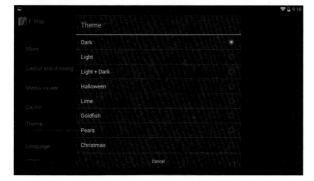

Image 3.26 ▼ F-Stop New Album.

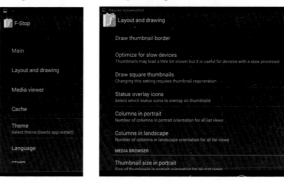

Image 3.27 ▼ F-Stop theme options.

Image 3.28, 3.29 ▼ F-Stop settings.

Image 3.30 ▼ F-Stop main settings.

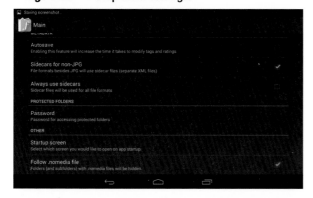

Image 3.31 ▼ F-Stop viewer settings.

Image 3.32 ▲ Port4Droid home screen.

Image 3.33 ▲ Port4Droid settings.

Image 3.34. Port4Droid preferences.

Image 3.35 ▲ Image Import dialog box.

Image 3.36 ▲ Album viewing options.

Port4Droid. Port4Droid also comes in free and paid versions. The free version allows you to manage up to 150 images. That may seem like quite a few, but it's really not. In my five portfolios, I currently have nearly 200 images. The paid version is about $3 and can only be purchased from inside the app.

The biggest difference between this app and other gallery apps is that Port4Droid does not scan the device to look for images. It only contains images you put into it. This makes it a true portfolio application.

The user is offered three options for importing images: Albums, Portfolios, and Photos. Photos would be used to house individual images. Albums could be for collections of images that may include images in portfolios but also other images of a certain type that may still be appealing but not portfolio material. Portfolios is where your best of the best would be found—the ones you show to others as your mobile portfolio.

Because I don't warehouse photos on my mobile devices other than for my mobile portfolios, I only use the Albums page of Port4Droid (**image 3.32**). If you have larger image collections on your phone or tablet, all three storage options may be useful to you.

When you import images into the app (**image 3.35**) you're presented with a choice. You can choose to create a copy of the image or to create a link to the image. Since the images are already on the device, there is no sense in creating a copy. That will just eat up storage capacity, which is at a premium anyway.

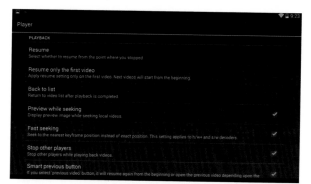

Image 3.37 ▲ *(left)* **MX Player home screen.**
Image 3.38 ▲ *(right)* **MX Player settings.**

Image 3.39 ▲ **MX Player settings.**

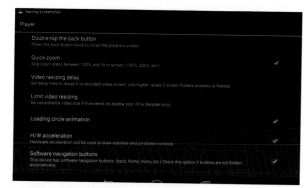

Image 3.40 ▲ **MX Player settings.**

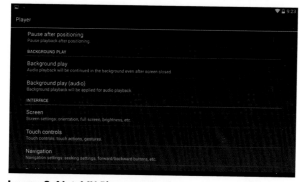

Image 3.41 ▲ **MX Player settings.**

Image 3.42 ▲ **MX Player settings.**

The app also allows you to link to Flickr and 500px, so you can import images from your Web portfolios without having to transfer them from your computer. Just sign in to your account and approve access for the app.

To delete an album, portfolio, or photo, long press on it to bring up a new toolbar. From this screen, additional items can be selected. Long pressing will also allow you to create a copy of the image or collection or to rename it.

▶ Videos

The gallery apps discussed can warehouse videos, but you will need another app to play them. As with the image gallery, there is a stock video player on Android devices. As with the stock image gallery, the video player is very limiting. It is not compatible with several popular video formats, including MP4, and there are no custom options available.

MX Player (**images 3.37–3.42**), available at the Play Store, comes in both free and paid versions and is very good. It plays a wide variety of video file types and offers a high level of customization. Like many free apps, this one is ad-supported, but you won't see ads when the video is playing, only in the main screen and when a video is paused. If that's not acceptable, consider the paid version, which costs a little over $5. Interestingly, there is no option in the app to upgrade to the paid version. You will have to go to the Play Store and do it there.

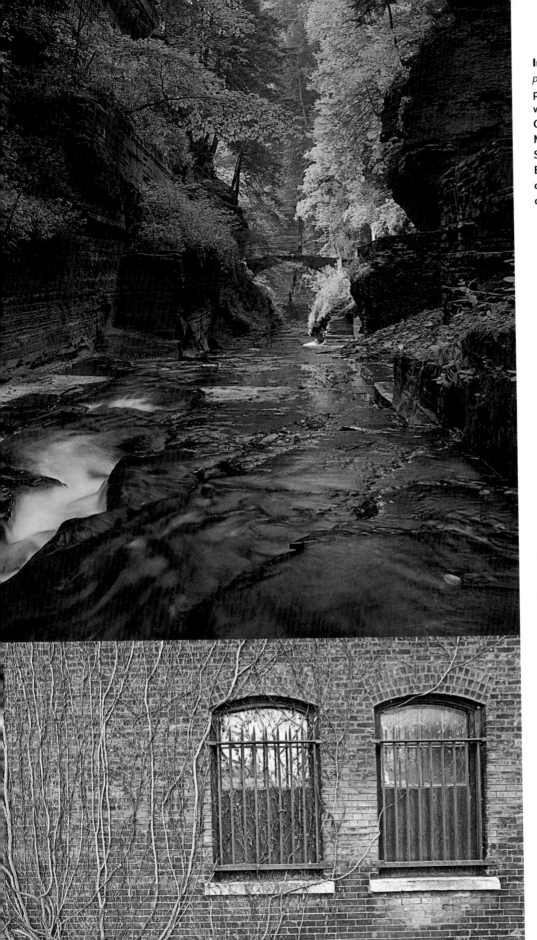

Image 3.43 ▶ *(facing page)* Eleven-shot multiple exposure of a pathway into the woods at Chutes Provincial Park, Massey, ON, in autumn. Shot on a Canon 5D. Each shot was captured at ISO 100, $1/15$ second, and f/8.

Image 3.44 ◀ Upper Falls, Robert H. Treman State Park, NY. Canon 5D, ISO 100, 2 seconds, and f/22.

Image 3.45 ◀ Vines overgrowing vacated Hook & Ladder 8 in Buffalo, NY. Nikon D700, ISO 200, $1/15$ second, and f/8.

4. Mobile Camera Control

There are many reasons why we want to, from time to time, control the camera remotely. The cable release, in any of its forms, from the old-school plunger style to the new-fangled electronic versions, has helped photographers control their cameras remotely for decades.

Camera shake is something that we work hard to avoid, and remotes help us do that. For slow shutter speed photography on a tripod, the cable release lets us fire the shutter without touching the camera. It serves the same function for firing off an exposure bracket sequence for High Dynamic Range (HDR) merging. Touching the camera during a bracket sequence can cause movement, which will hinder proper alignment of the images during the HDR merge. There are specialist remotes that can allow us to set up delayed exposures or do time-lapse sequences. More and more gear, more and more "stuff" to pack, and more and more "stuff" to have to root through when we're looking for the right thing in the bag.

> Touching the camera during a bracket sequence can cause movement, which will hinder proper alignment of the images during the HDR merge.

A smartphone or tablet, a USB cable, and the appropriate app make that task much easier and put full control of the camera at our fingertips. With these apps you can control the aperture, shutter speed, and ISO. You can touch the screen to focus, do focus bracketing, set up exposure bracketing sequences, change the metering pattern, and much more. In addition to still capture, these apps also let you capture video and use the screen of your device for composition and focusing. One, in particular, that we will look at a bit further works via WiFi, so you don't even

Image 4.1 ◀ Inside the disused Buffalo Central Terminal train station, Buffalo, NY. Nine-shot HDR bracket with a Nikon D700. Merged and tonemapped in Photomatix.

Image 4.2 ▲ Close-up impressionistic image of magnolia blooms in the Royal Botanical Gardens, Hamilton, ON. The camera was rotated during the exposure. Nikon D700, ISO 200, .8 second, and f/22.

have to be near the camera. This is great for setting up a blind to photograph birds or other wildlife. It also works well for devices that don't offer USB host functionality.

The number of these apps is growing in the Play Store. Some are still in beta development but, even with that, are quite well sorted and usable. There are free and paid versions of most. The free versions typically limit the functionality and are designed to see if the app will work with your particular camera. They may place a watermark on the image or limit you to JPEG capture, as examples.

All work similarly but, obviously, the interfaces are a bit different. One, DSLR Controller, is only available for Canon cameras at present, but the developer does plan to add Nikon and, perhaps, other manufacturers once he feels the app is ready for full release with Canon. It's one of the ones that is in beta development. Despite that, it may be the most fully

sorted of all the ones available. Like any other apps, some offer more functionality than others.

In the discussions that follow, I've concentrated on the ones that provide the greatest functionality, as I believe this is what would be used by readers of the book. The ones that will be discussed are Helicon Remote, DSLR Dashboard, CamRanger, and DSLR Controller. As I stated in the introduction, the discussions of these apps won't be a replacement for any user manuals or FAQs that are available on the app websites. I'm going to go over basic functionality and operation but won't get into the deep, nitty-gritty details of the apps.

Image 4.3 ▲ Helicon remote Exposure tab.

Image 4.4 ▲ Exposure mode choices.

Image 4.5 ▲ Aperture setting.

Image 4.6 ▲ Exposure compensation.

Image 4.7 ▲ White balance.

Image 4.8 ▲ Flash settings.

Image 4.9 ▲ ISO settings.

▶ Helicon Remote

Helicon Remote is a mobile app produced by the company responsible for the popular Helicon Focus software (www.heliconsoft.com). The remote app, unsurprisingly, features a robust focus bracketing functionality. Focus bracketing is used for enhancing depth of field by taking a series of images at different focus points from front to back then merging the images in software. The software uses the most sharply focused areas from the series of source images to create a single merged image with greater depth of field than could be achieved with a single shot.

The app is available in free and paid versions. The free version restricts you to JPEG capture only. The paid version costs $14 and removes this restriction. Payment for the unrestricted version is done on the Helicon website and you receive a registration code which is input via the app settings. Even though you are paying outside of the Play Store, you still receive updates as issued.

Given that the app is coming from a large software company, as opposed to an individual programmer, it is not surprising that Helicon has the best look of all the apps we will be examining. It uses a simple but efficient tabbed format for the different functions.

The Exposure tab (**image 4.3**) is where you set the general camera parameters. There are choices for shooting mode, shutter speed (only active in Shutter Priority or Manual), aperture (only active in Aperture Priority or Manual), full manual, or fully programmed automatic. You also select your ISO, exposure compensation, file type, and white balance. Depending on the size or orientation of the device you are using, you may have to scroll down to see the last few parameters. Below white balance you have the parameters for your flash as well. If you choose Color Temperature in the white balance dropdown, the next dropdown will become active and allow you to select a specific Kelvin value. You can turn Live View on or off from this screen and take a still image (**images 4.4–4.9**).

The software uses the most sharply focused areas from the series of source images to create a single merged image with greater depth of field . . .

On the Focus tab, the focusing bracket feature is set up (**image 4.10**). The arrows at the top left allow you to move the focus position of the lens in large, medium, or small increments. The amount of movement of the large and medium steps can be set in the app preferences (the gear wheel). To set the first focus

Image 4.10 ▶ Helicon Focus tab.

point, adjust the focus of the lens to the near position of your focus stack and long press on the A button. This will lock the focus point into the app. Next, using the arrows, move the focus of the lens to the far focus point and long press the B button. The arrows have to be used because this allows the app to count the number of steps between the two points and determine the number of shots. The Direction dropdown allows you to determine whether the focus bracket starts at the near or far focus point. If the Auto box is checked, you will see the number of shots to be taken and the interval between shots. This is determined by the aperture you have selected on the Exposure tab. A smaller aperture will mean fewer shots, a larger aperture more shots. You can override this by unchecking the Auto box and manually inputting the number of shots or the interval. Changing one will automatically change the other.

The DOF button will tell you what the total depth of field will be for the shot. It is stated in terms of Helicon's focusing steps, which is not easily relatable to feet, inches, meters, or centimeters.

You can use the Auto Focus button to tap the screen and focus the lens at one end point in your bracket. You still have to use the arrows to move the lens to focus on the second end point.

The Preview button simply gives you a preview of the shot at the current focus point, sort of like a digital Polaroid.

Press Start Shooting to begin your focus bracket.

With a recent update to the app, the A and B focus points are now also active in video capture mode and can be used to do a rack focus between two subjects. This is something I communicated with Helicon about and they agreed that it would be a good feature to add. Unlike the A/B focus shift in DSLR Controller, discussed further on, the focus shift is very smooth and can easily be used to do a seamless rack focus during a video shoot. The next step, and I'm told it is coming, is to allow the user to adjust the speed of the focus shift for faster or slower rack-focus adjustments.

The Live View tab (**image 4.11**) has a couple useful features. For Canon users, it will provide a depth of field preview. The Highlight focused areas is a focus-peaking function. This is very useful for

With a recent update to the app, the A and B focus points are now also active i video capture mode and can be used to do a rack focus between two subjects.

determining where in the frame your focus point is. Unfortunately, this function is not "sticky," so each time you launch the app, or if Live View times out, or every time you take a picture, you have to turn this back on. Making this a feature available in the app Preferences menu and being able to leave it turned on at all times, only turning it off when desired, would be a positive development.

The Highlight overexposed areas is not overly useful, particularly if you have the histogram showing on the display. With the histogram active, you can see whether or not you have clipping on the histogram. The overexposure highlight, effectively like the blinkies on the LCD of your camera, can tell you how much of the image is overexposed and you can then decide if you want to adjust the exposure. I've not found a reason to turn it on, personally.

The last tab, Tools (**image 4.12**), is where the real fun happens. Here you can set up your exposure

Time-lapse allows you to set up a repetitive sequence of shots for creating a time-lapse video—another plus for Canon shooters who don't have this functionality in their cameras.

bracketing for HDR. If you are a Canon shooter, you will be happy to know that you can override the three-shot AEB restriction in most Canon bodies. Time-lapse (**image 4.13**) allows you to set up a repetitive sequence of shots for creating a time-lapse video—another plus for Canon shooters who don't have this functionality in their cameras. Some Nikon bodies have a built-in interval timer and some don't, so this is useful for Nikon users too.

Start Recording Video is pretty self-explanatory. Press it to start video capture, press it again to stop.

Image 4.12 ▲ Helicon Tools tab.

Image 4.13 ▲ Time-lapse settings.

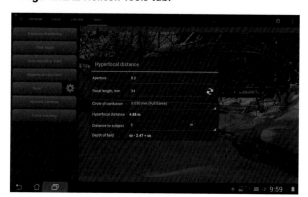

Image 4.14 ▲ Hyperfocal calculator.

Image 4.15 ▲ Burst mode.

Images 4.16–4.20 ◀▲ Helicon settings.

You can use the arrow buttons on the Focus tab to adjust focus during a shoot. I wouldn't recommend this because the buttons move in jumps, even at the small increment stage, which would not look good in video. While you can set up the screen to autofocus by tapping, I wouldn't recommend doing that to focus in video either because the lens will sometimes hunt to find focus. Manual focus with the ring on the lens and the focus peaking feature turned on will be the ideal way to use the app for focus during video. Once the A and B focus points are activated for video capture, using those for a rack focus will also be possible. Helicon has also said they will consider allowing the user to adjust the speed of the focus shift so that the speed of a rack focus can be adjusted. That too will be a cool feature once implemented.

Pressing the gear wheel at the top right of the screen opens the app Preferences menu. I won't walk through all of the available settings, as most are self-explanatory. Suffice it to say that Helicon gives the user a fair degree of customization of the app to suit the particular needs of the individual.

The menu button on the very far right is where you will input your registration code if you purchased one, as well as the other, usual suspects of functions—providing feedback, getting help, details about the app, and the exit button.

► DSLR Dashboard

Dashboard is one of those apps from an independent programmer, like many other apps on the Play Store. That doesn't mean it's bad by any means. In fact, it's very good. At present, it is free and there are no ads to clutter the interface. It may become a paid app in the future, so get it free while you can. There is a companion user e-guide for the app titled *Instant Guide to DSLR Dashboard* that walks you through the various features and functions of the app. It only costs $2 on Amazon, and updates are available for free from the link in the back of the book. I'd highly recommend buying the guide and having it available on your device for quick reference.

Image 4.22 ▲ DSLR Dashboard main screen.

The interface is very different from Helicon. It has much of the same functionality, but the controls are laid out differently (**image 4.22**).

On the left side of the screen are the main camera function buttons. The camera icon at the top triggers a still image capture. AF will focus on the active focus point in the live view screen. You can also tap in the screen on the image to change the focus point

Image 4.21 ▼ Shadow of a young tree in autumn on the side of a dilapidated panel truck in a wrecking yard near Kitchener, ON. Nikon D700, ISO 200, ¹/₆₀ second, and f/11.

Image 4.23 ▲ Top menu options.

Image 4.24 ▲ Focus stacking.

Image 4.25 ▲ Advanced exposure bracketing.

Image 4.26 ▲ Burst mode.

Image 4.27 ▲ Time-lapse settings.

Image 4.28 ▲ Settings.

and refocus. The small light in the upper left of the image area will be red or green depending on whether the camera was able to attain focus. Rec begins and stops video recording. Off sets any shutter delay and the Tag icon at the bottom allows you to invoke any camera presets you have established. This is useful if you shoot in some specific conditions repeatedly. You

simply load the preset and your camera settings are adjusted to the variables in the preset.

Along the top are what we will call the secondary camera functions. We will skip the LR Timelapse button for now and come back to it later. The Mode button switches between the various exposure modes. Host Mode will always be brown and simply means

the Android device is acting as the host for the camera. Lv toggles Live View on and off. The Bkt button offers an advanced exposure bracketing feature. This is more useful than the Bkt button on the right, which we will get to later. Because of the improved functionality, I recommend using this Bkt button rather than the one along the right side. Focus Bkt is a similar function to the feature in the Helicon app. The difference is that you are unable to set start and stop points. Rather, you tell the app how many images to take and the step between images. The combination of those two determines how deep the focus shift will be. The icon that looks somewhat like a clock is the time-lapse setting. The functions here can override or add to functionality that exists in the camera. For example, on my D800 I can set up a normal time-lapse where individual images are captured, and I create the time-lapse movie later or I can set it up to create the time-lapse movie in-camera and save that to the memory card. On my D700, though, there is no time-lapse movie function in the camera, but if I wish, I can have that functionality in the app. If you are shooting RAW for your time-lapse sequence, then I would advise against creating the clip with the app. You will want to, at least, do some minimal editing of your RAW images, so there is no sense creating the clip at the time of shooting. If, on the other hand, you shoot JPEG for your time-lapse sequence, then there is not a great benefit to creating the clip later because your JPEGs are already processed and the flexibility of RAW is lost (see the "RAW and JPEG" sidebar in chapter 3). Next is a microphone button. This one is interesting. It allows you to set up the camera to be triggered by sound. It uses the microphone in the device as the receiver for the sound trigger. It works quite well. Next to that is the Information panel. This will bring up a screen with your current camera and lens parameters visible. That is followed by the Image Review icon. Pressing this will allow you to review images you have taken. You can select to view images resident either on the device or the camera and, if the camera has multiple card slots, which card. You can transfer images to and from the device or camera and delete images. This is handy for quick image review and provides a better view than the LCD on the back of the camera. The app is not actually decoding the RAW image; rather, it is using the JPEG embedded inside the image for preview. Selecting an image by pressing on it will open another screen with a larger view. Here you can zoom in or open a histogram for the image. Keep in mind that this is a JPEG and not the actual RAW image, so the histogram won't be completely accurate. Lastly, in the upper right is the Settings icon. Here you can set up the app the way you want (**images 4.23–4.30**).

The Tag icon at the bottom allows you to invoke any camera presets you have established. This is useful if you shoot in some specific conditions repeatedly.

Down the right side of the screen are what I'll call the image-specific parameters. The Capture Area you see in the screen shot is something that is available for certain Nikon cameras that offer different shooting modes. The Nikon D800, for example, allows the

Image 4.29 ▲ Settings.

Image 4.30 ▲ Settings.

user to shoot in full frame, APS-C cropped frame, or 4x5 cropped frame. This parameter cannot be changed from within the app; it has to be changed in the camera. This is simply a reference for what image area is currently active. Next down is the image type. If JPEG is selected, you can choose from Large, Medium, or Small with the next icon. ISO is below that, and White Balance is next. Metering allows you to change the metering pattern. Focus Metering is camera dependent and determines what type of metering will be used and how it is tied to the focus

pattern. Next down is the focus type: Single, Continuous, or Manual. Capture Mode is either Single Shot or Continuous. Whether you can change this setting in the app or whether it is information-only will be dependent on the camera. Next is the Burst sequence. This determines how many shots will be taken in a burst. Below that you can set exposure compensation, and below that the step of any Exposure Compensation. Next down the list is the Picture Style or Picture Profile. These are camera dependent and only come into play when shooting JPEG. Next is an icon for

Images 4.31–4.32 ▼ *(left and right)* **DSLR Dashboard right side menu options.**

Image 4.33 ▼ Aperture setting.

Image 4.34 ▼ Program mode.

Image 4.35 ▼ Image settings.

Image 4.36 ▼ ISO settings.

Image 4.37 ▲ White balance.

Image 4.38 ▲ Metering type.

Image 4.39 ▲ Exposure delay.

Image 4.40 ▲ Focus point selector.

Image 4.41 ▲ Image copyright options.

Active D-Lighting. This is a Nikon-only feature. Flash allows you to select the flash sync and red-eye reduction. Below that is Flash Exposure Compensation. This is different from total exposure compensation above and varies the power of the flash only. The Bkt button allows you to set up an exposure bracket. As mentioned above, I would ignore this and use the Bkt button at the top of the screen for more advanced bracketing features. Below Bkt is the icon that lets you determine what type of bracket you want to do such as exposure, flash, or white balance bracketing. Moving further down the list is the focus point selector. Next, you can select where the images are to be saved. I'm not sure what SDRAM does for saving the images, so keeping this on SD card is advisable. Lastly, you have an icon for Image Comment. This allows you to write some information into the image metadata. You can include a comment on the image. This could be project name, place name, whatever you like. You can also include copyright information. I have the copyright information enabled. This saves me some time later when I bring the images onto the editing computer in my office (**images 4.31–4.41**).

Those are the main functions of the app. As you can see from looking at the screen shot, there are more icons and information boxes.

Along the bottom left of the screen, the box with the arrows will let you toggle full screen mode on or off. The focal length of the lens is listed to the right of that. Toward the middle you have shutter speed, aperture, and an exposure meter. This is like the meter in the viewfinder of the camera that tells you if you are over- or underexposed based on the current

Image 4.42 ▲ BLV (red arrow).

Image 4.43 ▲ Display Options icon (red arrow).

Image 4.44 ▲ Display and focus options (red arrow).

camera settings for ISO, aperture, and shutter speed. Pressing shutter speed or aperture will allow you to change those values depending on what mode you have the camera in (aperture priority, shutter priority, manual, or program). On the right side of the bottom is the camera battery indicator. Beside that is an estimate of the number of shots available on the memory card. The camera icon at the bottom right will toggle between camera settings and video settings. Pressing it to switch to Live View gives you a new selection of options along the right side of the screen. What functions you have access to will depend on the camera. If the camera is capable of shooting video, your video parameters will show up here. If the camera captures only still images, your selections will be reduced.

BLV (**image 4.42**) is an interesting feature. It only works when you are in full manual mode and only on some cameras. It is, effectively, an exposure lock. It's useful, for example, when composing a shot in a studio setting where you are using strobes and the modeling lights are not powerful enough to allow you a bright enough image for focusing. BLV stands for Bright Live View. Select to enter Live View and set your exposure parameters using the fields at the bottom of the screen. Now, press BLV and it will turn red. This locks your chosen exposure settings. You are free to change the exposure settings for the Live View display only, and your shot settings remain in memory. This way you can brighten the screen to focus without affecting your shot settings. Press the capture button and the stored exposure settings are used to capture the image. When the display returns to Live View after the shot, the BLV settings are, once again, applied. Pretty neat!

The mountain icon (**image 4.43**), which is also duplicated inside the image preview area, allows you to choose to display a histogram, to turn a composition grid on or off and, perhaps most importantly, offers a number of other display options which can aid in focusing. Right at the bottom of the list is Focus Peaking (**image 4.44**). As with Helicon, this is very handy for determining accurate focus both in stills and video. For video, it is particularly handy when adjust-

180 Degree Shutter Rule

Like most "rules" in photography, this is more of a guideline than a hard-and-fast rule. The "rule" is a holdover from movie cameras and is an important component of getting the "film look" to video, if that is what you want to achieve.

Unlike still cameras, which have a focal plane shutter that opens and closes, movie cameras have a rotating wheel as a shutter. This wheel rotates at a certain speed, and the wheel will have cutouts that expose the film for certain periods of time. The smaller the cutout, the shorter the exposure time. The "standard" in movie shooting is to use a 180 degree shutter wheel. With a 180 degree shutter, the wheel is a half disc. The wheel spins at a rate that is dependent on the frame rate you are shooting at. In order to expose the entire frame of film, the wheel has to spin at a rate such that the frame of film is exposed for exactly half the frame rate. So, for half the frame rate the film is exposed, for the other half of the frame rate, the film is moving from one frame to the next. This means that your shutter speed is, effectively, one-half your frame rate. If you are shooting at 10 frames per second (fps), your shutter speed is $1/20$ second. The "standard" for movies is to shoot at 24 fps. Your shutter speed, for a 24 fps film, then needs to be $1/48$ second. The closest we can get with a DSLR is $1/50$ second. So in order to use the 180 degree shutter rule for video, you want to use a shutter speed of $1/50$ second at 24 fps. At other frame rates, simply do the math to come up with the appropriate shutter speed. 30 fps? $1/60$ second. 60 fps is $1/120$ second (or the closest shutter speed your camera is capable of).

The idea of this rule, particularly with videos where you want a "film look," is that this shutter speed allows for a small amount of motion blur in the frame—not enough that it is visible on-screen, but just enough to allow for fluid movement between frames. Using faster shutter speeds can lead to a stuttered or, in some cases, stroboscopic look, which isn't pleasant to view.

The standard for video, as opposed to film, is 30 fps and, thus, a $1/60$ second shutter speed. It's the reason why early video was not appealing to filmmakers because it had what they called a "video look." It didn't have the fluid movement of film.

Sports are often shot at 60 fps, where the faster shutter speed and faster frame rate is necessary to properly display the fast movement in the action of the game.

The 180 degree rule also applies to time-lapse video. If you want to output your time-lapse at 24 fps, your shutter speed should be $1/50$ second or even slower. You can get away with a bit slower shutter speed in time-lapse because the nature of this style is often a bit stroboscopic. Don't go too slow though, or you will end up with nothing but blur. If you are doing time-lapse on something with fast action, then consider halving your shutter speed. For example, if you would normally shoot hockey with a shutter speed of $1/400$ second, drop that down to $1/200$. That will give the bit of blur you want for continuity. Otherwise, your clip may look more like stop-motion than time-lapse.

ing focus during a take. The LV button allows you to toggle between still and movie live-view settings if your camera supports video capture. The next button down is a zoom of the Live View display. Next, we get into the video-specific camera settings. For shooting video, you use these buttons to set your exposure rather than the fields at the bottom of the screen.

You can shoot video in any of the available modes. As with still capture, the camera will adjust the other settings based on how you adjust the one setting that is left to you. I would advise shooting video in full manual mode if your camera offers it. This gives you the most control of the end product and allows you to make the choice to use the 180 degree shutter rule or not. The exposure scale at the bottom of the screen will indicate whether you are correctly exposed or not. The Live View display will change brightness based on your chosen settings, but this is not necessarily a good indicator of proper exposure. You can dial in exposure compensation, but I would not use this for

Image 4.45 ▲ LR Timelapse options.

Image 4.46 ▲ LR Timelapse options.

video. Adjust your aperture, shutter speed, and/or ISO manually to alter the exposure.

Below the Exposure Compensation icon are a series of additional video-specific options that are also camera-specific. These will be consistent with the features your camera offers, so reviewing your camera manual will refresh you on what these functions do.

► LR Timelapse

LR Timelapse (LRT) is a piece of desktop software that works in conjunction with Lightroom. The main purpose of LRT is in evening out exposure variations for time-lapse photography. Exposure variations, even very small ones, that may not be visible to the eye in viewing two still photos side by side can become very noticeable in a sped-up video clip. This unevenness of exposure between shots is called flicker. Flicker can be annoying to look at, and it can make an otherwise

very good time-lapse clip just another ho-hum time-lapse.

The main source of flicker is the lens aperture. Automated apertures, as are used by most people in today's lenses, remain open at the widest aperture until the shutter is fired, at which point they close down rapidly to the aperture set on the camera. This rapid closing down of the aperture is not necessarily exact. There can be small variations in that action, which causes small variations in the actual aperture the image is recorded at vs. the aperture set in the camera. Keep in mind I am talking about very small variations.

LRT analyzes the exposures of all the shots in a sequence and effectively edits the shot metadata to compensate for the variations, thereby removing flicker from the final time-lapse clip.

LRT has another function. The "Holy Grail" of time-lapse is a clip that encompasses the changing exposure from day to night or night to day, sunset or sunrise. In order to do this, the exposure has to change continuously throughout the shoot to compensate for the changing light conditions. Hardcore time-lapsers will use the Bulb mode of their camera and a special remote release to control the exposure in Bulb mode. Most cameras are limited to a 30 second maximum shutter speed in one of the automated modes. In Bulb mode, there is no maximum. The shutter will stay open as long as the shutter release remains pressed or the electronic signal exists via a remote release. By adjusting the shutter speed in Bulb mode, time-lapsers are able to bridge the day/night gap quite well. This process is called "bulb ramping." With specially built remote releases, shutter speeds can be adjusted in hundredths or thousandths of a second. DSLR Dashboard can also do this on the main screen when in Bulb mode. Users are able to adjust shutter speeds in increments of $\frac{1}{1000}$ second, which makes bulb ramping possible using DSLR Dashboard. There may be limitations in the camera being used as to how short a shutter speed can be set using the USB port to control bulb exposures. Several Nikons have such a

limitation. You will need to experiment to see if your camera does or not.

The LR Timelapse feature of DSLR Dashboard does not give us that much fine control. The intent with this feature is to allow us to capture a set of images using varying shutter speeds and/or ISO settings to bridge the day/night time frame, and then we can feed these images into LR Timelapse and have it smooth out the exposure variations even further. There is also an "Auto Holy Grail" feature that will analyze images as they are captured and automatically adjust the shutter speed or ISO setting to compensate for the changing light levels. It does this by analyzing the histogram of the captures and averaging out the histograms from the ten previous exposures and making adjustments accordingly.

The LR Timelapse features of DSLR Dashboard are still in development, so an in-depth discussion of the functions is not going to be relevant because there could be significant changes as this part of the app is further refined.

Image 4.47 ▼ Burleigh Falls in spring, near Peterborough, ON. Shot on film with a Mamiya C330 TLR.

Image 4.48 ▲ CamRanger Data tab.

Image 4.49 ▲ Exposure mode.

Image 4.50 ▲ Aperture setting.

Image 4.51 ▲ ISO setting.

Image 4.52 ▲ Metering mode.

Image 4.53 ▲ Drive mode.

▶ CamRanger

Similar to the other apps as it offers remote control of the camera, CamRanger is very different in that it offers wireless control to the photographer. This affords a level of freedom that the other apps do not. It allows you to set up the camera and then, if necessary, move away from the camera and remain out of sight. Shooting wildlife and setting up the camera in a blind would make the CamRanger useful. Or, if you just want to take a rest when shooting, you can sit in a comfortable chair and still control the camera. CamRanger is also great if you have an Android phone that does not offer USB Host functionality.

CamRanger works through a small, lightweight module that plugs into the camera and acts as its own WiFi hotspot. Your mobile device connects to this

hotspot, and the signals for camera control are sent back and forth. The CamRanger connects to the camera via USB and comes with a neoprene pouch that attaches to a tripod with a Velcro strap so that there is no weight on the USB connection.

The app is free; the CamRanger unit costs $299 and can be purchased at camranger.com. Setting up the connection between the CamRanger module and your mobile device is simple. Open the WiFi connections on the phone or tablet and scan for new devices. The CamRanger should show up. There may be a slight delay. Once this is done, press to connect. On the back of the module is a sticker with the serial number. You will need to input the serial number to activate the CamRanger on each mobile device you want to use it with. This needs to happen just one time for each phone or tablet.

The user interface for CamRanger is very clean and well laid out. The majority of the screen is taken up by the image with the various camera controls on the bottom (if the device is in portrait mode) or the right (if in landscape mode). Similar to Helicon, CamRanger works on a tabbed approach with the tabs grouped by function. CamRanger was originally designed for Apple i-devices and is still in beta for Android. Despite being in beta, the app works well, but there are a few functions that aren't yet operational.

On the main Data tab (**image 4.48**), you are able to turn a live histogram on or off. The first, large button in the user controls is for the camera operating mode (aperture priority, shutter priority, manual, or program). Below that are the options for shutter speed, aperture, ISO, and metering pattern. If any particular control is not available, it appears in a darker shade of gray. In the next row are buttons for the drive mode, white balance, and image type. Below that is an option that isn't yet in operation. The icon that looks like an exposure meter is the bracketing and exposure compensation selection. Next to that is the AF mode the camera is on.

The bottom row of buttons controls live view, movie recording, and focus. The Live View (an eye)

is used to turn the live view feature on or off. The movie camera button switches between still capture live view and video live view. Doing so also changes the Capture button in the lower right of the image window to a Record button. AF (autofocus) determines whether the camera will autofocus before each image is captured. In MF (manual focus), you can still tap the screen to focus. When in video live view, the only additional functions available are the video focus choices of manual, single, or continuous. None of the other video options are adjustable in CamRanger (**images 4.49–4.56**).

Image 4.54 ▲ White balance.

Image 4.55 ▲ Image format.

Image 4.56 ▲ Exposure compensation.

Image 4.57 ▲ Focus tab.

Image 4.58 ▲ Timer tab.

Image 4.59 ▲ HDR tab.

Image 4.60 ▲ HDR settings.

Image 4.61 ▲ HDR settings.

Image 4.62 ▲ HDR settings.

Image 4.63 ▲ HDR settings.

Image 4.64 ▲ HDR settings.

The Data tab offers the ability to turn a histogram on or off. When reviewing an image from the top image bar, the histogram for the image will be displayed.

The Focus tab (**image 4.57**) allows you to adjust focus manually with the arrows. The size of the arrow determines the step or amount of focus shift. You can do focus bracketing in this tab as well. There are no options, at this point, for adjusting the size of the focus steps, nor the ability to turn on focus aids such as peaking. The focus stacking feature is not as complete in CamRanger as in Helicon. The focus moves incrementally away from the camera so you want to start at the nearest focus point. Without knowing how much focus shifts with each change, it is difficult to determine how many shots are needed for a proper stack. It becomes a bit of a trial-and-error process. According to my communications with the developers, they do plan to make some enhancements in this area of functionality, which may include the ability to add A and B start/end points, focus peaking, and rack focus during video capture.

The Timer tab (**image 4.58**) is for doing time-lapse capture. Live view must be turned off for this to work. You set the number of shots and the delay between shots and let the CamRanger do the rest. Pretty simple. There is also a bulb function that allows you to control the camera in Bulb mode. The camera must be set to Bulb mode for this to be active.

The HDR tab (**image 4.59**) is for advanced AEB functionality. The app must be in Manual mode for HDR to work. Live view must also be turned off to enable the advanced bracketing functions. Using the Property dropdown, you set what variable you want adjusted. This can be aperture, shutter speed, or ISO. Shutter speed is the one you want to vary. Varying aperture will alter the depth of field, which can create a merged image with oddly in- and out-of-focus areas and make alignment of the source images difficult. Varying the ISO value really makes no sense, as you can introduce noise to the merged result, and noise reduction is one of the prime advantages of HDR. You have to manually set the starting shutter speed

Image 4.65 ▲ Rotate button (red arrow).

Image 4.66 ▲ Camera model and number of shots remaining (red arrow).

(or aperture or ISO value). The HDR mode will not take the shutter speed you have set up in the exposure variables. Tell the app how many shots to take and the exposure step between each shot, and it will do its thing. You are able to override the in-camera bracketing limitations using this feature of CamRanger (**image 4.59–4.64**).

The Rotate button (**image 4.65**) in the lower left of the image window will rotate the live view image in the screen 90 degrees with each press. I have yet to find a use for this function.

At the top left of the screen you will see the camera model that is being used and an estimate of the number of shots left on the memory card (**image 4.66**). Toggling to full screen can be done with the Full Screen switch on the upper right. This is useful if you want a bit larger image for fine focusing or if you want to review what you are seeing on-screen with someone

Image 4.67 ▲ App settings.

Image 4.68 ▲ App settings.

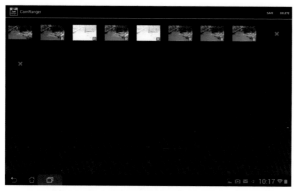

Image 4.69 ▲ Image review screen.

Image 4.70 ▲ Image review screen.

else before capture. The app settings (**imags 4.66 and 4.67**) are accessed at the top far right. There are a few options here. The most notable is the PC mode. This offers access to a wider range of functions within the app than the Cam mode, and I recommend using PC.

▶ DSLR Controller

DSLR Controller is, at this point, a Canon-only app. The developer indicates that he does plan to create versions for Nikon and perhaps other manufacturers, but not until he is fully satisfied with the status of the app for Canon. While the app is still in a beta stage, it is very well sorted and quite full-featured. The cost is about $8. While it is somewhat unusual to pay for a beta version, keep in mind that these are independent developers and you are paying for their development time, which is not insubstantial.

The developer of DSLR Controller has been concentrating solely on use of the app with Canon cameras. As a result, he has been able to create a very clean and effective user interface. When I speak with some of these developers, most of whom are independents, about adding other camera models or adding an Android version to an existing iOS version, they universally talk about how difficult it is to try to find the time to do all that they want to do. The result is that some apps are a bit hackneyed in terms of the user interface. The developers concentrate on functionality at the expense of user ease of use. Not so with this one.

The layout is similar, in some regards, to DSLR Dashboard, with camera functions around the outside and the image view in the center of the screen (**image 4.71**). What functions are available will depend on the camera being used.

Starting at the upper left is the mode the camera is in currently—M(anual), Av, Tv, P(rogram), or B(ulb). The mode cannot be changed in the app; it must be changed in-camera. You can change modes in the camera while the app is open. Tapping the Mode button will allow you to change the focus function from single to continuous and the metering pattern in

Image 4.71 ▲ DSLR Dashboard main screen.

Image 4.72 ▲ Focus mode.

Image 4.73 ▲ Metering mode.

Image 4.74 ▲ Focus stepping.

Image 4.75 ▲ Focus type, the smile is Face Detect.

Image 4.76 ▲ Picture style.

Image 4.77 ▲ Drive mode.

Image 4.78 ▲ White balance.

Image 4.79 ▲ Shutter speed.

Image 4.80 ▲ Aperture.

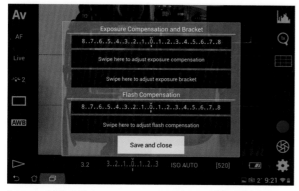

Image 4.81 ▲ Exposure compensation and bracketing.

Image 4.82 ▲ ISO setting.

the second and third icons respectively. Tap the Mode button again to return to regular function of the app. The AF button allows you to tap the screen to focus automatically. Tap the AF button to access manual focus functions. Included here is an option for setting up A and B focus points. Use the arrows along the bottom of the screen to move to your first focus point, then long press on A to set that point. When the point is set it will change to A. Use the arrow to move focus to the second point and set it the same way to setting B. You need to use the arrows so the camera knows how many steps to move between focus points. The size of the steps can be changed with the buttons at the top of the screen. The focus shift is quick but not completely smooth; it moves in discrete steps. As a result, using the A and B points for smooth focus pulls may not work for you. There is no ability to adjust the speed of the transition. The focus shift will happen more quickly with larger steps, however. Care has to be taken in setting the focus points. If you continue to hold the arrow even past the end, near or far, focus point of the lens, the app will continue to count steps, and when you press to go back to the other focus point, it will overshoot. The Quick button will switch between normal autofocus and live view autofocus. Face detection can also be turned on here. Next is the Picture Style selection, below that the Drive Mode for single, continuous, or self-timer settings. Lastly, there is the white-balance control (**images 4.72–4.78**; previous page).

Moving to the bottom of the screen, the first arrow takes you to the image review screen where you can review previously captured images. Shutter speed and aperture are next. Which of these is visible will depend on what mode you are in with the camera. The middle control is exposure compensation, which will be inactive in manual mode. Tapping any of the available controls will open the Selections dialog box. In square brackets after the ISO settings is the number of shots available on the card and then a battery indicator. This is the battery for the camera, not your device (**images 4.79–4.82**).

On the right side of the screen at the top you can choose to turn the histogram on or off. Next is a button to be able to zoom into the image, which is beneficial for attaining accurate focus. The grid button offers a selection of several different framing aids, including 16:9, which is useful for video. The red button is for starting and stopping video capture. The iris captures still images, and the gear wheel takes you into more advanced settings (**images 4.83–4.84**).

In the advanced settings, you will see selections for image review, shutter open time for Bulb mode, HDR, focus bracketing, interval timer operations, bramper, Fullscreen mode, WiFi Passthrough, camera-specific information, and the option to sync the time stamp in the camera to your device. In the next panel, you have options for camera functions including the type of image, video format, silent shooting, strobe recharge delay, and focus pull step delay. Below that you have

Image 4.83 ▲ Channel histograms.

Image 4.84 ▲ Grid overlay.

Image 4.85 ▼ Using a creative white balance setting rendered this shot very cool. Impressionistic camera pan of a wooded area in Enniskillen Conservation Area, Enniskillen, ON. Nikon D700, ISO 200, 1 second, and f/18.

Image 4.86 ▲ Bulb mode shutter speed.

Image 4.87 ▲ HDR parameters.

Image 4.88 ▲ Advanced bracketing.

Image 4.89 ▲ Focus bracketing.

the configurations for the live view settings of the app; you can set up focus peaking here as well. After that are settings for image review, then where images will be stored. Below that you can determine whether the app starts in live view automatically and how continuous and Bulb shooting work (**images 4.86–4.90**).

HDR capture only works in manual mode, and you determine what variable is chosen for the bracketing. The number of shots that can be taken is virtually unlimited. Focus bracketing is used for focus stacking, as in Helicon Remote, to create images with enhanced depth of field. This can also be combined with HDR bracketing. The time-lapse function allows you to choose the interval between shots and the number of shots to be taken. The app will then tell you how long the sequence will take to complete. This too can be combined with HDR bracketing. Keep in mind if you are going to do a time-lapse/HDR combination that your time between shots needs to take into account the

Image 4.90 ▲ Time-lapse settings.

cumulative time the shutter will be open for the bracketed sequence. For example, if you set a shot interval of five seconds but your shutter needs to be open for a total of 10 seconds to capture all of the shots in the bracket, your shot interval is meaningless. When you set the number of shots, you do not need to take into account the bracket multiple. So if you want to take

ten shots with a five-shot bracketing sequence, you only need to set the app to ten shots for the time-lapse sequence, not 50. Bramper is a function that is not yet set up and is for bulb ramping (again, this is the process whereby you manually adjust the exposure in small increments while the camera is in Bulb mode). It is used in time-lapse capture for periods when you are shooting in changing light conditions, such as sunrise or sunset, and are trying to capture the "Time-Lapse Holy Grail." Bramping allows you to work in Bulb mode but have very fine control over exposure so you can change it as the light changes. Fullscreen live view

is self-explanatory. WiFi Passthrough is a function that allows you to use DSLR Controller on a different device than the one connected to the camera. It's a more complicated version of CamRanger but serves a similar purpose.

I will not go over the camera configuration settings because those are pretty self-evident. The live view configuration settings are more important. Renderer Quality determines the quality of the image on the display of your device. I have not found a significant difference between the two Renderer Quality settings. Renderer Frame Limit determines the effective frame

Image 4.91 ▼ App options.

Image 4.92 ▼ App options.

Image 4.93 ▼ App options.

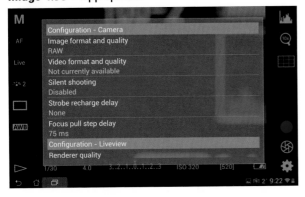

Image 4.94 ▼ App options.

Image 4.95 ▼ App options.

Image 4.96 ▼ App options.

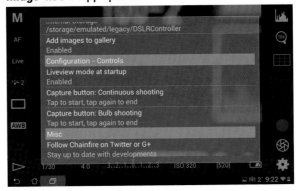

rate of the display on-screen. Faster means less lag between what is happening in your scene and what you see on the device. For still images, 15 fps is fine. For video, you want to sync this with your video frame rate (30 or 24). Use 30 if you are shooting at 60 fps. Focus Peaking is the same type of focus aid we have discussed before. It is a good aid for manual focusing and, in particular, is useful for video capture and changing focus during a shot.

The Review and Storage Location settings are not overly important, and you can set these up as you like. Personally, I would enable Live View at startup. It just makes using the app quicker and gets you working faster. The settings for Continuous and Bulb shooting are best set, in my opinion, to "tap to start, tap again to end." Otherwise, you have to tap and hold on the screen. My preference is to touch the screen of the device as little as possible. The phone or tablet will, in all likelihood, be attached to your camera or tripod or video rig, and having to continuously hold the capture button can induce and transmit shake to the camera.

As you can see, DSLR Controller has a cornucopia of options for the photographer or videographer. I have not covered every aspect of the app but have discussed what I consider to the be most important points. I very much like the apps available for Nikon cameras currently but will probably also install this one when the developer makes it compatible with other camera makes.

Image 4.97 ▼ Nine-shot multiple exposure of tulips at the annual Canadian Tulip Festival in Ottawa, ON. Nikon D700, ISO 640, and f/8.

Image 4.98 ▶ *(facing page)* Nine-shot multiple exposure of tulips under a large lilac tree at the annual Canadian Tulip Festival, Ottawa, ON. Nikon D700, ISO 640, and f/8.

5. The Mobile Digital Darkroom

To speak with some photographers, the digital darkroom is where the magic really happens. Other photographers will shun this notion as the refrain of the lazy; they, of course, feel that everything should be "right" in-camera. Somewhere in the middle lies reality. Well, okay, for some, all the magic happens in the digital darkroom but, from my perspective, we're moving more into graphic arts than photography. Enough of that debate.

There can be no debate that the digital darkroom is important. Even those "get it right in-camera" folks understand that they still need to use editing, at a minimum, to convert their RAW images into usable file formats.

We are probably all used to traveling with a laptop. We probably all also know that laptops are not wonderful for serious image editing. The screens are low quality with very poor viewing angle character-istics. They are hard to calibrate and have such poor contrast and color rendition that calibrating them is often a waste of time anyway. While hard drives in laptops have increased in capacity over the years and now may be large enough to hold a decent number of image files, few photographers consider their laptop hard drive to be primary storage. We will carry one, and often two or more, external hard drives that serve the purpose of primary and backup storage.

Laptops are heavy and take up a fair amount of space. Given the poor suitability for image editing,

Image 5.1 ▼ Rust to rust or, if you're a Neil Young fan, rust never sleeps. The rusted-out hull of this old Dodge sits on a laneway in the gentrified Distillery District of Toronto, ON. Nikon D800, ISO 100, 1/20 second, f/8. Photo Mate R2 was used for RAW conversion. Final editing done in Photoshop CC2014.

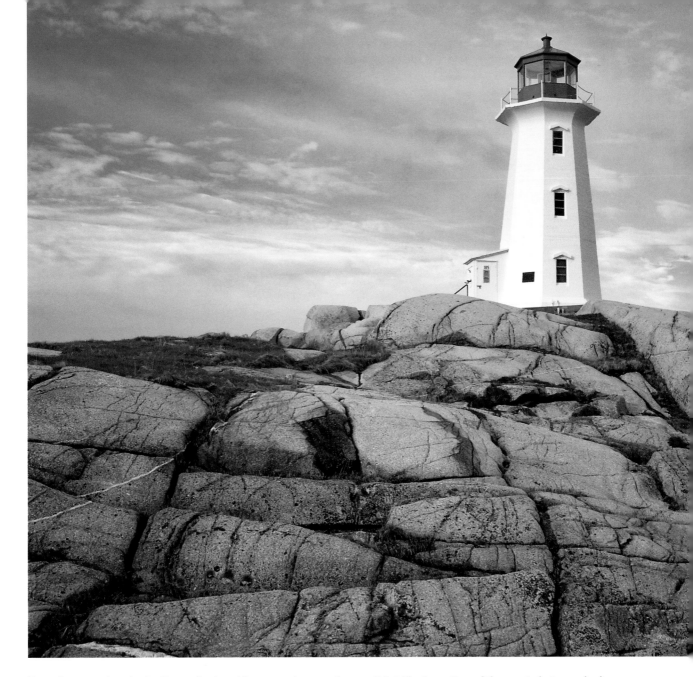

Image 5.2 ▲ The Icon. One of the most photographed spots in Canada. Peggy's Point Lighthouse at Peggy's Cove, NS. Shot on film with a Crown Graphic 4x5.

I've often wondered why I even bother (the exception being when I'm on assignment and have to have images ready for a deadline before I am going to be able to work them up in my office; then, I make do).

Enter the realm of the mobile digital darkroom: A small, lightweight tablet. A small, lightweight Bluetooth keyboard. One or two external hard drives of the wireless variety. Maybe a Bluetooth mousepad but maybe not. A screen that, if the right tablet is chosen, has vastly superior color reproduction and contrast when compared to a laptop. While it cannot be color managed, the screen is so much better and much more accurate out of the box than the laptop that it is still much more effective than the laptop. You'll need a

Image Organization

Image organization is a task that a lot of people take for granted—or ignore completely. That includes some professional photographers. Image organization is a task that should not be taken lightly, and developing an organizational process for your digital images will be key to maintaining a smooth workflow and to being able to find what you need when you need it.

Image organization is more than just keywords and color ratings, although those are important. The process of image organization starts with the folder hierarchy on your hard drive. A good folder structure will make finding images easier even without using keywords or other ratings.

There are many different philosophies that are suggested for developing your folder structure. I'm going to outline mine. You can use it, modify it, or come up with something entirely different. What matters is that you give this task careful consideration.

I am not a proponent of the idea of grouping by year. If you have multiple projects for the same client or at the same location in different years, finding all of those images can be difficult. I prefer a location or project-based folder structure.

If you are using Lightroom as your image database, I am also not a fan of multiple catalogs. In earlier versions of Lightroom, catalog size made a difference to performance. With current versions, this is no longer a concern. Lightroom has been optimized to take advantage of today's multi-core processors and systems with abundant RAM. Nor am I a big proponent of having a traveling catalog and a master catalog. If I need to take images out of the office, I'll make copies and put them on an external hard drive, which I can access on another system, but there really is not a need to have a separate traveling catalog.

Adobe Bridge does not use a catalog structure; many think of it as just a glorified file browser, but it is much more than that. All of the same organizational tasks that can be done in Lightroom or other database applications can be done in Bridge, and Bridge can also search for images based on parameters the user defines. It is a very powerful image-management tool.

Images are broken down into two categories in my structure: commercial and personal. Personal doesn't mean non-commercial; it just means the images were not shot for a specific client. When it comes to commercial, I group by client, then by project for that client. Within each project folder I have folders for RAW, TIFF, and JPEG, so everything is kept separate. The way I provide images to my clients is that, unless the contract is amended to call for something

card reader, of course (which you would have with the "traditional" laptop-based solution). There you have it. The mobile digital darkroom.

When it comes to reviewing, organizing, transferring images from place to place, and editing, there really is only one app to use. It is the only app in the Android universe that truly decodes RAW images. Others use the term RAW in the app name, but all those do is pull the preview JPEG image that is embedded in the RAW file. You can't actually do anything with the RAW images. The app to use is Photo Mate R2 (PMR2). PMR2 is the successor to the terrific program Photo Mate Pro. The developer wanted to add so many new features that he decided to start with a fresh slate rather than continue to add onto the existing version. It costs under $9.50 on the Play Store. It'll be the best $10 you spend on an app. There are other very good apps for working with images, but those all work only on JPEGs. Is PMR2 as good as something like Lightroom or Adobe Camera RAW? No. But it is not that far off, and it does a terrific job for the price. I am confident that the app will continue to be refined and improved over time.

At this point, there are no other apps that can decode RAW images. Photoshop Touch offers many of the editing tools we know from the full version of

different, I give them full-resolution TIFF files and smaller, Web-ready JPEGs. If I want to, I can delete the JPEGs after the images are delivered to the client because those can always be quickly re-rendered from the TIFF images. A typical folder hierarchy would look like the one below:

> **Commercial**
>> **Client A**
>>> **Project A**
>>>> **JPEG**
>>>> **RAW**
>>>> **TIFF**
>>> **Project B**
>> **Client B**
>>> **Project A**

When it comes to personal images, I prefer to organize by location. If I shoot in multiple areas within a specific location, those will be sub-folders inside the main folder. As an example, I've shot in multiple cities in the province of Ontario, so I have a master folder for Ontario. Each city is a sub-folder below that with the image-type folders inside that. Multiple locations within a city will have their own separate sub-folders. The same RAW, TIFF, and JPEG structure is used here as well, so a sample folder structure might look like this:

> **Ontario**
>> **Toronto**
>>> **Kensington**
>>> **High Park**
>>> **St. Lawrence**
>>>> **JPEG**
>>>> **RAW**
>>>> **TIFF**

You can see that it follows the same basic pattern as for commercial images. When it comes to images I want to use for a specific purpose, such as stock, keywords come into play. I will use the word "stock" as a keyword, along with other relevant keywords. When it comes time to find a particular image I can search for the term "stock," plus other words, to find what I want. The Collections feature of Lightroom or Bridge can be used to maintain the sub-collections for each type of stock image. For example, I will have a master collection titled Stock, then inside that are sub-collections for the different types of images. I would not advise using the hard drive folder structure for this purpose because you would be duplicating files on the hard drive. Image organization tools that have a collections feature and use virtual copies of images are built for just this type of secondary organizing need.

Photoshop, but it only works on JPEGs. If the rumored launch of Lightroom for touch devices happens, then we may have another application that can work on RAW images—but, for now, it's PMR2. Adobe is notoriously slow in releasing apps for the Android platform as well, so even if a mobile version of Lightroom is released, it may only be for iOS. That, however, is not a bad thing. PMR2 is a very robust and full-featured application with, as you will see shortly, an interface that Lightroom users will find strikingly familiar.

PMR2 has been well thought out by the developer and allows the user to access and manage images in multiple places. It can access images that are resident on the device, housed on wired external storage (such as a card reader or hard drive) and on WiFi hard drives via the networking features of the app. The app is also updated on a regular basis for new camera RAW formats and with enhancements to the editing functionality.

The app also allows you to do some initial organizing of images by providing the ability to add keywords and to rate images using stars or colors. These organizational tasks can be done to individual images or a batch. The one utility that I believe is missing—whether you believe it is missing will depend on whether you use it or not—is the ability to geotag images.

Geotagging

Geotagging or geocoding is a process whereby locational attributes such as longitude and latitude are embedded into the metadata of a digital image file. Place names and even addresses can also be added.

Geotagging first became popular as people began sharing more and more images on the web. Geotagging allows you to pinpoint a location so that you can find it again if you want. It also allows people who are researching a topic or trip to search for photos of that place. Photo buyers are also using geocode information to search for images they may need for a project.

The process is quite simple. You record a tracklog as you move. This tracklog contains locational datapoints, which are time-coded. You then use other software to match up the locational data points with where your pictures were taken based on the time stamp in the metadata of the digital image file. To create the tracklog, you can use a dedicated GPS receiver or, since we are talking about mobile solutions, an app from the Play Store.

You will want to record your tracklog in the .gpx format. Some apps—GPS Logger for Android is one—allow you to choose to record in either .gpx or .kml format. Lightroom and most other geotagging applications take tracklogs in the .gpx format. Converting a .kml file to .gpx can be done, but it is another step in the workflow and can lead to errors in the conversion process. Look for an app that allows you to capture the tracklog in .gpx format.

Geotagging is not a perfect process. There are variables that can impact how complete or accurate your tracklog is. Buildings, nearby electronic equipment, canyon walls, and even trees can sometimes interfere with capturing data points. The quality of the app in using the GPS receiver in your device as well as the quality of the GPS receiver in your device can also impact the completeness and accuracy of the tracklog.

The app settings will allow you to set up the parameters of capturing your tracklog. You may be given a choice of using cell phone towers or satellites. Choose satellites for increased accuracy. Frequency of data point collection can be determined either by distance or time. I use time, but distance can work as well. The less time or distance between data points, the more accurate your geotagging process will be. Obviously, tracklog files will be larger when capturing data points more frequently, but the files are quite small to begin with so file size should not be a concern. I have tracked routes for upwards of ten hours, and the file is still only in the kilobytes in size.

Geotagging is quite easily accomplished in Lightroom and other desktop applications (see sidebar, this page). If it is able to be done while away from the office, it becomes just one more step that gets you closer to actually editing your pictures when you come back to your office. The more that can be done in the mobile digital darkroom, the more efficient the editing process can be in the office.

Let's start with the process of bringing images into PMR2. PMR2 is not a database, but it does have a robust file browser.

▶ Transfer from Memory Card

I don't recommend transferring images directly from the camera to a hard drive. The process is slower than by using a dedicated card reader, and if the battery on the camera runs out, your transfer process will be interrupted, which may also corrupt some image files.

There are two ways to transfer files from a card reader using PMR2: wired or wireless. Let's start with wired.

Wired Image Transfer. If you have a small number of images to transfer, a wired connection to transfer images to either the internal storage of the device or an accessory memory card is possible. Keep in mind the caveat I noted earlier in the book about using a laptop, or in this case the mobile device, as primary storage.

Transferring files to the device should only be an intermediate, temporary measure before moving them off to an external hard drive or two.

You will need your OTG module or cable for this. Plug the OTG module into the device, then connect your card reader. You should see a small icon in the notifications bar indicating the external storage has been mounted. With Google Nexus devices, you may be prompted to use the Nexus Media Importer. If you are,

confirm the selection. Within the Media Importer you can select the images, then copy them to a storage location on the device. Check the Preferences section of the Media Importer to disable pasting into a default directory and set up your own if you wish.

If you are using a non-Google device, then in PMR2, navigate in the file browser to the USB storage device. Tapping on Storages in the upper

Image 5.3 ▶ I absolutely love doors and windows. I'm fascinated by the colours and styles. Toronto has no shortage of interesting ones. This one is in the Kensington area of Toronto, ON, which I favor almost as much as the St. Lawrence Market as a shooting locale. Nikon D700, ISO 200, $^1/_{30}$ second, f/8. Photo Mate Pro was used for RAW conversion. Photoshop CC2013 was used for final adjustments.

Image 5.4 ▼ Baby heirloom tomatoes at the St. Lawrence Market in Toronto, ON. Nikon D800, ISO 640, $^1/_{125}$ second, f/2.8. Initial RAW editing in Photo Mate Pro and final adjustments in Photoshop CC2013.

Image 5.5 ▲ Confirmation of USB card reader connection (red arrow).

Image 5.6 ▲ Look for the folder labeled Removable.

Image 5.7 ▲ Navigate through the nested folders.

Image 5.8 ▲ Navigate through the nested folders.

Image 5.9 ▲ Navigate through the nested folders.

Image 5.10 ▲ Tapping on Storages in the upper right shows internal and USB storage locations.

Image 5.11 ▲ Choose Multi-Select from the menu.

Image 5.12 ▲ Multi-Select is active.

Image 5.13 ▲ Image files selected.

Image 5.14 ▲ Choose Copy from the menu.

right should show the connected card reader, which is quicker than going through the file browser. Open the nested folders as necessary to get to the image files. Select the image files you want to move by going to the menu, tapping Multi-Select, and choosing the desired images (go to the menu and choose Select All after selecting a single image if you want to copy all the images on the card). In the menu choose Copy, navigate to the folder you wish to place the images in on your device and, from the menu, choose Paste. The images will be copied to your mobile device (**images 5.5–5.15**).

The process of moving images to the device from the memory card is very simple. You can now edit the images in PMR2. Once the editing is complete, you can move the images from the device to your external storage along with the .xmp files that are created as a result of any work you do on the images. Yes, that's right: PMR2 stores all your keywords, ratings, and edit information in .xmp sidecar files, which are easily read by other applications such as Lightroom, Adobe Camera Raw, and Adobe Bridge. Integration with your desktop editing workflow is seamless.

Moving images via wired connection to the device is pretty simple. Now we will take a look at moving from the camera's memory card directly onto the external hard drive via WiFi. I am using the Patriot Gauntlet Node as my WiFi hard drive. Others may have a slightly different process, but it shouldn't be that much different.

Image 5.15 ▲ Tap the clipboard (red arrow) to paste images into the specified folder.

Wireless Image Transfer. You will need to set up your wireless hard drive as a connection on your tablet. Follow the instructions provided from the manufacturer to do that. You can set up security on the WiFi drive if you like. I don't want people to be able to connect to the drive, so I have set up security.

Connect your card reader to the tablet as with a wired transfer, then connect to the wireless hard drive in the WiFi settings of the tablet. You should have a notification in the task bar indicating the external card reader is connected.

Open PMR2 and navigate to the Network window in the main menu (**image 5.16**). You will see a list of the network storage locations you have access to. Press the icon for your wireless hard drive and navigate to the folder on the WiFi drive where your images are stored. You can create a new folder here to begin the organization process—or you can just dump everything

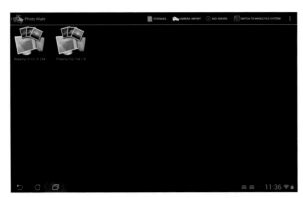

Image 5.16 ▲ Network connections in PMR2.

into the main folder and do the organization when you get back to your office. The point of being able to do it while mobile is to make the workflow more efficient, so I recommend creating the new folder now. When you get back to your office, you can simply copy the folder structure and images to your desktop hard drive and have your image library software, Lightroom in my case, import the images without copying.

With the folders created on the WiFi drive, go to the PMR2 main menu and choose Switch to Whole File System. This will bring you back to the master drive structure. You should see a folder titled Removable or something similar (**image 5.6**). This is your USB card reader. Open the folder where your camera images are stored. Choose Multi-Select from the PMR2 menu, then choose Select All from the top taskbar. Go to Copy in the PMR2 menu, then go back to your WiFi hard drive in the Network menu. Open the folder where you want to paste the images and select Paste from the top taskbar. WiFi is fast, but it will still take some time for the images to copy over to the drive.

The Patriot Gauntlet I use has an interesting built-in security feature. While you can view data on the drive via the wireless connection, you are unable to edit or alter data on the drive while it is wireless. At first, this may seem a bit odd, but it prevents someone unknown from altering your data easily if they access the drive. Putting security on the drive will also prevent unauthorized tampering, but many people will not do that, so this is a stop-gap to give users a bit more protection. The net result is that once the files are transferred over to the wireless drive, you will need to connect it via cable to the tablet to begin editing your image files. This is fine because you no longer need the card reader connected so your OTG USB port is free to connect to the hard drive. The wireless hard drive you use may not have such a feature, in which case you can immediately start editing. The Seagate Wireless Plus, for example, does not have such a security feature. You can, however, put a password on the connection to prevent unauthorized access. When you attach the cable to your tablet you will see the same external storage notification in the taskbar. The nice thing about the Gauntlet is that it charges via a dedicated DC plug or via USB. USB charging is slower. Since it does charge via a DC plug, you can have it connected to your tablet and do your editing while the battery in the drive is charging.

Adobe Process Versions

A Process Version is what Adobe uses to refer to the manner in which it decodes and renders RAW images for on-screen viewing and how it applies the parametric edits you apply to the image.

The first such Process Version was 2003. This was updated in 2010. The only change at this time was the way in which noise reduction was handled. The most recent update is to Process Version 2012. This version is a complete rethink of the way Adobe applications handle RAW files. The parametric editing controls are completely different. Some like the new approach, some do not. Many users were con-fused with the change in controls and how the adjustments worked on the image.

PMR2 uses something that is akin to the 2003 Process Version. I have asked the developer if he plans to update to the 2012 and have been told there are no such plans. That is not a big problem. Lightroom and Camera Raw are backward-compatible with previous Process Versions. If you update the Process Version on your computer, the Adobe application will convert your adjustments using the older version to the newer as best as possible.

Image 5.17 ▲ Batch options in PMR2 (red arrow).

Image 5.18 ▲ Batch options.

Image 5.19 ▲ Convert Images options (red arrow).

Image 5.20 ▲ Image conversion utility.

▶ Image Organization

Let's start with the image organization features in PMR2. You can assign keywords and star and color ratings to individual images or a batch.

In the main image preview window, choose Multi-Select from the main menu. Tap to highlight multiple images, then press Batch Options in the taskbar. It's the icon with the three small stars (**image 5.17**). A new window will pop up that allows you to give ratings and assign keywords. You can save this as a template if you want so that you can apply it to other images quickly (**image 5.18**). Input your keywords and ratings, tap Apply, and those settings will be applied to all the selected images. When finished, tap Multi-Select to deselect the images.

The Convert Images option in the taskbar—the icon with the three small image thumbnails (**image 5.19**)—will batch convert the selected RAW images to another file format. You have several options for the conversion including where to save the converted files, renaming, and to resize (**image 5.20**). You can also choose the quality setting for JPEG conversion and include a watermark in the images.

The editing controls offered in PMR2 are quite robust. I mentioned previously that the user interface would look very familiar to anyone who uses Lightroom. The controls and functionality are much the same as the pre-version-4 editions of Lightroom. When you transfer images to your office computer and open one in Lightroom or Camera Raw, it will be noted as the 2003 Process Version (see sidebar, facing page).

▶ Image Editing

The image browser of PMR2 uses the JPEG embedded inside the RAW file for the thumbnail preview

Image 5.21 ▲ PMR2 image browser.

(**image 5.21**). When you press to open the image inside the editor, the decoding process takes place. This is true RAW decoding too. You are applying parametric adjustments to the actual RAW image.

Double-tapping on the image will zoom in to 100%. At the top of the screen, in the taskbar, you have options for turning on exposure markers for highlight clipping, shadow clipping, or both. In the menu there is an option for turning on a histogram. Interestingly, when turning on the highlight/shadow markers, not just the image you are working on is marked, but all the images in the scroll at the side are also marked. Scrolling down the toolbar, you have all the recognizable sliders. White Balance adjusts the overall color hue of the image. Moving right increases the color temperature, moving left decreases it. You can also choose from the standard white balance presets in the Preset dropdown. Tint adjusts for green/magenta shifts. Move left to increase green/reduce magenta, move right to do the opposite. There is an eyedropper to do a tap in the image for white balance. Brightness affects mainly the midtones in the image. Exposure is a straight adjustment to the exposure value across the image. Contrast affects both dark and light tones. Increasing contrast deepens darks and brightens lights, thereby increasing contrast. Lowering the contrast slider does the opposite. Recovery applies exposure reduction to highlight areas only to help with overexposure correction. This adjustment is pretty well isolated to the highlight areas, but you can get some bleed into the midtones if you push it too far. Fill Light allows you to brighten dark shadow areas a bit to help with shadow underexposure. Fill Light is a control you want to use with a light touch because it can quickly cross over into the midtones and even some brighter

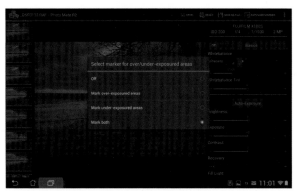

Image 5.22 ▲ Exposure marker options.

Image 5.23 ▲ Histogram menu selection.

Image 5.24 ▲ Develop Module adjustments.

Image 5.25 ▲ Develop Module adjustments.

areas. Blacks sets the black point for the image. Moving to the right increases black density. Clarity is a local or edge-contrast adjustment. Increasing clarity enhances edge contrast, which gives the appearance of greater sharpness. Pushing the Clarity slider too far can create a grungy look to the image. Reducing clarity produces a soft-focus filter effect. Vibrance affects colors that are undersaturated. Saturation affects all colors equally. Colorize Strength and Hue are adjustments that allow you to add an overall color cast to the image. This can be helpful, for example, in creating an aged look with a yellow tinge. It could also be used to give a sepia or cyanotype look to a black & white image. In general, for most work, this really is not a useful addition in my view. With any of the controls, resetting to the default is accomplished by double-tapping on the name of the control (**images 5.22–5.25**).

In the Details panel, the controls here are used as expected (**image 5.26**). Sharpness is, essentially, another local contrast control. The amount of the effect is determined by the Radius. You are best to zoom into the image, either by double-tapping or pinching out, so that you can see the effect of sharpening and noise reduction more accurately. Use of the Noise Reduction adjustment should be made sparingly. It is quite easy to overdo and blur the image. It is also difficult to get a good zoom level to assess the effect of the noise reduction. This is one adjustment that is likely better left to the desktop computer in the office.

The Lens Adjustment controls (**image 5.27**) work to fix barrel and pincushion distortion. Move to the left to correct pincushion distortion, to the right to fix barrel distortion. Scale adjusts the size of the image. Vignette adds a dark or light vignette. While these corrections do work, the extent of the corrections available is more fulsome in other RAW conversion packages, so I tend to do these corrections in Lightroom or Camera Raw, rather than PMR2. There are also adjustments for chromatic aberration. Due to the zoom issues noted above, this is another adjustment that is likely best left to the desktop computer.

Image 5.26 ▲ Detail adjustments.

Image 5.27 ▲ Lens correction adjustments.

Image 5.28 ▲ Color adjustments.

In the Color Adjustment panel (**image 5.28**), you are able to make adjustments to the hue, luminance, and brightness of any of the eight color families. This allows you to have excellent control of the color, tone, and brightness within the image. Desaturating all the colors, then working with the Luminance sliders, also provides a similar level of control to black & white conversions as you would have in Lightroom/ACR.

Image 5.29 ◀ Effects and filters.

Image 5.30 ▲ Gradient filter on image.

Image 5.31 ▲ After adjusting Gradient filter.

Image 5.32 ▲ Brush filter on image.

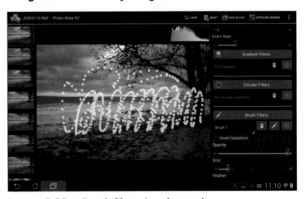

Image 5.33 ▲ Brush filter size changed.

Image 5.34 ▲ Clone controls.

Image 5.35 ▲ Large clone area established.

Below the Color Adjustment panel are several new features that have been added to PMR2. Effects allows you to add a grain-like look to the image.

The next set of filter panels (**images 5.29–5.35**) gives the user quite a bit of control over the image. Each does exactly what it says. Gradient filters allows you to draw a gradient on the image and then adjust all of the various image parameters on that graduated area. Circular gives you the option of creating—surprise!—a circular or elliptical selection. Brush is a free-form option where you draw on the image to create the selected area. Lasso does just what you would expect and allows to you draw a line around an object or area. You are not able to combine two filters into a single adjustment; each has to be adjusted separately. Any adjustments you made to a previous filter are automatically applied to a new filter. It would be preferable if each filter started at the default settings. Tap the + to create a new filter, then draw on the screen to create the filter mask. You do need to adjust the location of the filter before releasing pressure on the screen because it cannot be repositioned or adjusted afterward. Unlike Lightroom or ACR there is no "pin" you can use to reactivate the filter or move it around. You can add to a Brush filter by tapping the Pencil icon and the size of the line can be adjusted using the Size slider. Moving your finger or stylus more slowly in the image will create a continuous line and moving faster will create a more dotted line. Using the X/Y Offset controls, it is possible to do cloning in the image with several of the filters. The Feather slider determines how hard or soft the edge of the selected area is, which will impact the smoothness of any adjustments made with other parts of the image. Tapping the garbage can icon will delete the active filter. These are quite powerful additions to the editing functionality of PMR2.

Selecting the Curves option (**images 5.36–5.37**) will overlay a Curve dialog box right on the image. You can work on a combined curve or the individual color channels. The one issue I have with the Curves tool is that it applies a bit of a gray box over the image

Image 5.36 ▲ Curves control opened.

Image 5.37 ▲ Curve applied to image.

as well, which makes seeing the full effect of the curve adjustment difficult. As a result, it may take a couple attempts to get the result you want. The white circle is the overall RGB curve. Each separate channel has its own circle, which is activated by tapping on it. The last circle on the right is a saturation adjustment. It allows you to adjust the saturation levels of the highlights and shadows of the image somewhat independently. There will, of course, be overlap in

The last circle on the right is a saturation adjustment. It allows you to adjust the saturation levels of the highlights and shadows of the image somewhat independently.

Image 5.38 ▲ Image after adjustments.

Image 5.39 ▲ Left/right comparison.

Image 5.40 ▲ Top/bottom comparison.

Image 5.41 ▼ The leaves of a wild violet growing in my backyard. Nikon D700, ISO 200, ⅙ second, and f/16.

order to maintain gradation. This adjustment is useful, for example, to tone down saturation that may be too high in shadow areas. We need light to see color, and sometimes shadow areas can be too saturated. This allows us another option; the filters above are another, to adjust saturation selectively in the image.

Below the Curves panel is Preview Quality and the comparison options (**images 5.38–5.40**). This affords you the ability to quickly see before-and-after versions with the before on the top or bottom, left or right. The Preview Quality alters the image and adjustment quality on-screen. I would recommend keeping this at High or Very High for the best results. Undo and Redo commands are next.

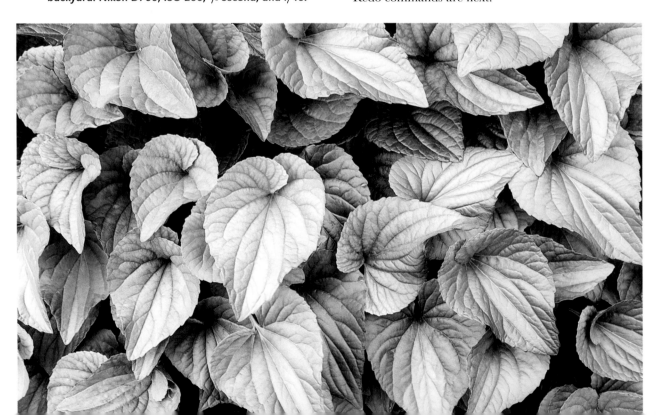

The edits you make to a single image file can be saved as a template for use on other images. Choose Load Template (**images 5.42–5.43**) to apply a template to a single image. In the Batch Options, on the other hand, you can open the select the Choose XMP Template window in order to apply a template to multiple images.

On the top task bar is an icon to open the cropping tool (**image 5.44**). With this open, you are able to crop the image. The app allows for the use of existing, fixed aspect ratios or a free crop. Hold and drag the control points on the bounding box to crop the image. Tap Save to apply the crop and go back to the Develop Module (**images 5.45–5.47**).

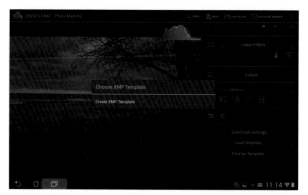

Image 5.42 ▲ XMP Template screen. Choose Existing or Create New.

Image 5.43 ▲ XMP Template Creation screen.

Image 5.44 ▲ Crop utility (red arrow).

Image 5.45 ▲ Crop controls.

Image 5.46 ▲ Crop controls.

Image 5.47 ▲ Crop controls and Save (red arrow).

Image 5.48 ▲ B&W conversion, Saturation reduced to –100.

Image 5.49 ▲ B&W conversion, adjusting the Luminance controls.

Image 5.50 ▲ B&W conversion, Luminance controls adjusted.

Black & White. PMR2 also makes it possible to create black & white images in much a similar way as Lightroom or Camera Raw.

Move the main Saturation slider all the way to the left (**image 5.48**). Now in the Color Adjustment panel, choose Luminance, and adjust the mix of the different colors to affect the gray tones in the image. You are able to very effectively create really nice black & white images in a way that is quite comfortable due to the similarity with Adobe products. You can also move the individual Saturation sliders all the way down and then work with the Luminance controls to accomplish the same result (**image 5.49–5.50**).

As you will see when you go back to the main image preview window, any of the images you worked on now show a companion .xmp file (provided you do not have Hide XMP files turned on in the Preferences). This is where your ratings and keywords are stored, as well as any edits you made in the Develop window. These XMP-sidecar files can be read by many image-editing programs, including Lightroom, Camera Raw, and Bridge. When you view the image metadata in, for example, the Library module of Lightroom, your keywords will appear in the appropriate fields. When you open that image in the Develop module, the edits you made in PMR2 will be applied. The one thing that can't be done currently is to create snapshots for different versions of the image.

Image 5.51 ▲ App settings.

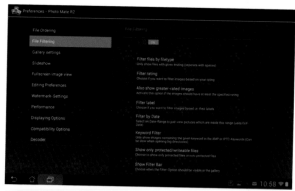

Image 5.52 ▲ App settings.

Image 5.53 ▲ App settings.

Image 5.54 ▲ App settings.

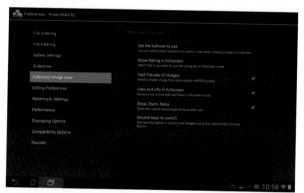

Image 5.55 ▲ App settings.

Image 5.56 ▲ App settings.

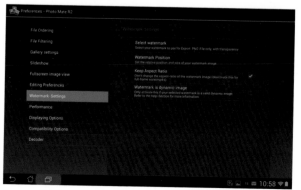

Image 5.57 ▲ App settings.

Image 5.58 ▲ App settings.

▶ Mobile in the Traditional Digital Darkroom

In addition to the powerful editing functionality we now have at our fingertips in a truly mobile solution, we can combine technologies and use mobile devices in the traditional digital darkroom.

Not a small number of photographers use graphics tablets such as those produced by Wacom. The high-end models that allow you to draw right on your image on the tablet run into the several thousand dollars. With an Android tablet and a couple of apps, we can achieve much the same thing for a lot less money.

The technology involves screen sharing via wireless connection. Both your desktop computer and tablet need to be connected to the same network. You need an app on your tablet and a companion program on the desktop computer. When you log into both, your desktop screen will be mirrored on your tablet (**image**

5.61). For working with Photoshop, I would not recommend using something smaller than a 10-inch tablet. Smaller than that and it becomes too difficult to see what you are doing, although you can pinch out to zoom in. There are several app packages for screen mirroring or remote desktop sharing in the Play Store. There are free and paid versions. The one I settled on for its ease of use and no input lag is Splashtop. I have tried others. Some have significant lag between input on the tablet and result on the desktop. Some don't properly mirror the desktop on the tablet. Splashtop just works. And the version I use is free. Bonus.

Install the mobile app on your tablet and the desktop software on your computer. You will need to create an account on the Splashtop website. Once you have done that, you can get connected. Launch the app on your tablet and on the desktop. Input your account credentials on both and you should be up and

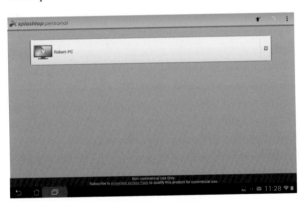

Image 5.59 ▲ Mobile device connection screen.

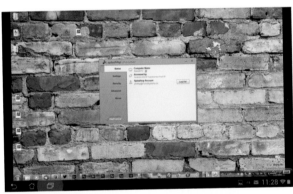

Image 5.60 ▲ Desktop application login screen.

Image 5.61 ▲ Desktop screen mirrored on tablet with Help icon at right (red arrow).

Image 5.62 ▲ Control panel.

running. On the desktop you can rename your computer if you wish. You can also implement additional security features such as requiring the desktop user account password to be input before a connection is made and you can set up a second, unique Splashtop password if you wish.

Once connected, you have the ability to fully control your desktop from the tablet. You can open programs, stream media, and create text documents or spreadsheets. Anything you can do on the desktop itself can now be done from the tablet as well.

What we are going to concentrate on is in using the remote desktop functionality in image editing. With this remote feature activated, you now, essentially, have the functionality of a very expensive graphics tablet in a tablet that cost only a few hundred dollars. Unfortunately, you cannot drag Photoshop tool tiles onto the tablet to use the tablet as a secondary display. If you do have two displays in use on your desktop setup, however, you can access both from the tablet.

Image 5.63 ▲ The red maple leaf looked interesting sitting on this large fungus in a wooded area called Courtice Trail in Courtice, ON. Nikon D700, ISO 640, $1/13$ second, f/5.6. This was converted in and edited in Adobe Camera Raw and Photoshop CC2013 using an Asus TF700 10.1-inch tablet as a graphics tablet through the Splashtop desktop sharing app.

You are only mirroring what you have on the desktop, you aren't creating another independent display. This can also be helpful in the studio as we will see in the next chapter.

Launch Photoshop or Lightroom or your editing software of choice from the tablet. In the lower right of the screen there is an icon for the various functions of Splashtop (**image 5.62**). At the far left is a disconnect button, which will end the streaming session. Moving to the right is the Help icon, which brings up hints about using the app. The next icon will lock the screen orientation even when the device is

rotated. That is followed by the icon to switch between displays. This will be an important one for us. After that is the scroll bar, which allows you to scroll up and down the page or document. Next is an icon for what is called Trackpad mode. This allows you to operate the tablet like a trackpad on a laptop. When not in this mode, any movement you make on the screen will cause some action to be performed. I prefer to work in trackpad mode so that actions are only performed when I want and how I want using the virtual mouse buttons at the bottom of the screen. Note, however, that trackpad mode disables the most of the touch functionality of the tablet. You are now using it like a regular trackpad with a mouse pointer and mouse buttons. To open a program on the taskbar or do anything else, you need to move the mouse pointer and use the virtual mouse buttons or tap on the screen like you would on a trackpad. You can still use the pinch-to-zoom touch functionality. The next button switches

the display on-screen from sharp with crisply defined detail to smooth. The smooth setting is too soft and it is difficult to read some text and see detail. The sharp setting is preferred. The last icon allows you to mute and unmute sound on the tablet. At the far right of the screen, when you have Trackpad mode turned on, you will see a mouse and gear wheel. Tapping that opens the settings for the mouse/trackpad function. The line with arrow opens and closes the function bar that we just described, and the Keyboard icon brings up the soft keyboard of the tablet. That's a quick tour of the functions of Splashtop. How do we use it in practice? Glad you asked.

You can work with your finger or a stylus using Spashtop. Being able to draw right on the tablet makes creating fine selections quite effective. The ability to easily zoom in using pinch enables even more refined selections. Rather than sitting over a keyboard and getting wrist strain using a mouse, we can sit more

Image 5.64 ▲ **View switched to Second Screen.**

Image 5.65 ▲ **Trackpad mode.**

Image 5.66 ▲ **Trackpad settings.**

Image 5.67 ▲ **Trackpad settings.**

Image 5.68 ▲ Selection drawn on image.

Image 5.69 ▲ Curve adjustment applied to selection.

Image 5.70 ▶
Result of curve
adjustment in
image; center
area lightened.

comfortably, with the tablet in our lap or on the desk and use any of the tools available in Photoshop or your editing program of choice. Being able to sit back in this manner also gives a bit better perspective on the tasks we are trying to accomplish. When we are sitting quite close, we tend to get a bit of tunnel vision and lose sight of the bigger picture. Sitting back allows us to see more of how an adjustment in one area of an image impacts other areas. Being able to sit more comfortably and farther from the screen can also help reduce eye strain. You will quickly get used to using the tablet as a graphics pad and will grow accustomed to the way the mouse functions.

Working on an image when zoomed in makes creating finely detailed selections easier in one respect but also more difficult in another. If you are zoomed in beyond the point where all the area you want to select is on-screen, using the standard selection tools such as the Lasso or Magnetic Lasso becomes more difficult. Anytime you stop holding the mouse button, your selection ends. Yes, you can add to it using the CTRL key. Even though the stock Android keyboard doesn't have a CTRL key, you'll notice that in the upper tool bar of Splashtop, all those function keys are present, including a CTRL key. But there is a better way. The Pen tool.

Image 5.71 ▲ Image zoomed in, using Pen tool to create path.

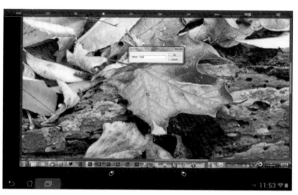

Image 5.72 ▲ Saving path.

Image 5.73 ▶ Path activated as selection.

The Pen tool is used to make a path, and paths don't stop when you release the mouse button (**image 5.71**). You can pick a path up from the last point just by clicking on the last anchor point. This way, you can work zoomed in, create part of a path, scroll the screen, continue to create the path, and so on. To close the path, match your last anchor point (the point where you release the mouse button) with the starting point of your path, then click on the starting point.

You now have a path but not a selection. We can deal with that. Paths can be saved with your image file for future use. To do this, go to the Paths palette. The path you just created will be named Work Path. Double click on the name Work Path. This will bring up a Renaming dialog box. Give the path any name

you like and click OK (**image 5.72**). Renaming is important. If you create another Path without saving the first one, your original will be overwritten. Your path will now be saved when you save and close the document. This is similar to layers. To convert the path to a selection, click on the dotted circle at the bottom of the Paths palette. Alternatively, you can press CTRL+Enter. You now have a very finely detailed selection in your image that you can go on to modify or edit with any of the other tools, the way you would if you had made the selection using any of the other methods (**image 5.73**).

Other tools you are used to using in Photoshop or Lightroom can be used the same way with your Android tablet acting as a graphics tablet.

6. The Mobile Studio

We have looked at how mobile can help us when we are away from our offices. We have looked at how mobile can help us to control our cameras in the field. Can mobile also help us in our offices and studios? Most definitely.

In the last chapter, we looked at how we can use an Android tablet as a graphics tablet to help in editing images in Photoshop or Lightroom. That was the start of the mobile studio concept. In this chapter, we are going to look at what we can do with mobile devices to help in a studio shoot with a model or portrait client. We will dig into how tablets can be used with commercial clients in the studio to allow them to preview what is being shot so that changes can be made on the fly or so that not everyone has to be crowded around a laptop screen. At the end of the chapter we will also dig into how tablets and phones can be used as supplementary lighting sources.

▶ Tethered Studio Shooting

Using Lightroom and Splashtop. Polaroids were crucial tools in studio photography in the film days. The photographer would take a shot with a Polaroid camera or Polaroid back then, examine the quickly developed image for lighting, posing, and other elements of the shot which could, if needed, be corrected immediately before putting the final shot onto film.

Fast forward to the digital era and we have built-in "Polaroids" in the form of the LCD screen on the camera back. There are a few drawbacks to the LCD-as-Polaroid, however. The image is small. Smaller than a Polaroid frame. Yes, you can zoom in, but then you lose the essence of the entire shot. If the

camera is positioned on a tripod, you have to take the camera off the tripod to be able to show the shot to someone on set. Clients peering over your shoulder to get a look at the preview are not going to get a good look at the image, and it can get a bit claustrophobic. Not to mention being hard on the eyes squinting to

Image 6.1 ▼ Locked? How secure is the lock on this door? Found in a back alley in the Kensington neighborhood of Toronto. Nikon D700, ISO 200, $^1/_{125}$ second, and f/8.

Image 6.2 ▲ Lightroom tethered Capture menu selection.

Image 6.3 ▲ Lightroom tethered Capture configuration.

Image 6.4 ▲ Lightroom Auto Import menu selection.

Image 6.5 ▲ Lightroom auto import configuration.

see, or the neck and shoulders from craning to try and see. To get around this problem, seasoned studio photographers continued to use analog Polaroids in concert with digital. They would take the preview with the Polaroid, then make the final shots with their digital camera. Medium format backs do have slightly larger LCDs, but the other problems still exist.

That is a lot of tooing and froing and a lot of extra steps that we need not take. Using a tablet, either a 7-inch or a 10-inch, we can shoot with the tablet tethered to the camera, get our preview image, untether the camera, show the preview to whomever needs to see it, make any corrections, then shoot. Wash, rinse, repeat as necessary.

For the workflow outlined next, I used Lightroom on a laptop, the tethered shooting capability of Lightroom and WiFi with Splashtop to connect the tablet to the laptop.

This may seem like a complicated setup, but it really isn't. Lightroom has a tethering capability (**images 6.2–6.3**) built in, and it works with many camera models. You connect the camera to the laptop via USB and launch the tethered shooting function from within Lightroom.

In order to have the images imported into Lightroom automatically, on the fly, you also need to set up the Auto Import feature. To do this, you'll need to set up what is referred to as a "watched folder." This is the folder that the images come into initially, and it needs to be empty (**images 6.4–6.5**). Then the images get transferred automatically to the destination folder you set up in the tethering screen.

Once that connection is made, you can launch Splashtop on both the tablet and the laptop. When Splashtop gives you the connection between the two devices, you are now streaming your laptop screen on

the tablet and are able to trigger the camera remotely with the tablet (**image 6.6**). This is really no different from what we did in the previous chapter using a tablet to work in Photoshop.

Your images will be captured into the Lightroom library as normal, and you can preview the image on the tablet (**image 6.7**). This allows the photographer the freedom to move around the set as needed. S/he can talk with a hairstylist or make-up artist about touch-ups, can adjust lighting, or talk with an assistant about what lighting changes to make, is able to show the model directly what the shot looks like (**image 6.8**), and with a visual representation of the shot, can better instruct the model on posing or position changes.

In addition, if there is a client on set, the client can be shown the image on the tablet screen and give approval on the spot.

If a retoucher is attending the shoot and working on the images, that can be done on the laptop and others can immediately see the results on the tablet. Alternatively, the photographer or retoucher can make adjustments to an image on the tablet in Lightroom through Splashtop, and the results can be viewed immediately.

This may be a different way of working for many, but once one wraps their head

Image 6.6 ▶ *(top)* Lightroom tethering utility mirrored on tablet using Splashtop.

Image 6.7 ▶ *(middle)* Photographer setting up shot on tablet.

Image 6.8 ▶ *(bottom)* Photographer discussing shot with model on the set.

Image 6.9 ▲ Images available for review in CamRanger (red arrow).

Image 6.10 ▲ Image Type setting (red arrow). Switch to RAW+JPEG.

Image 6.11 ▲ JPEG file-saving options (red arrow).

around it, it is a very freeing way of working because you are not tied to the camera or a laptop screen.

The same workflow can also be used for product photography.

Using CamRanger. As we saw earlier, Cam-Ranger allows you to control the camera with a phone or tablet wirelessly. This allows you to use the CamRanger and a tablet as a camera control/pseudo-Polaroid setup in the studio.

Your best option to do this is to set the camera to capture both RAW and JPEG simultaneously. Why? Because the JPEG images will preview much more quickly on the tablet than the RAW images will. If you are willing to wait the additional ten or fifteen seconds for the RAW images to load, don't bother with capturing both.

The CamRanger allows you to access images on the memory card by tapping the image on the filmstrip at the top of the screen (**image 6.9**). This will open a second screen that shows all of the images on the card. You can quickly preview different shots and make adjustments to the setup before moving ahead with the final shots.

Using Helicon Remote. Helicon Remote is a wired solution, but it can still be used to control the camera and check the setup or show images to clients.

This is possible because you are able to tell the app where to store images. You can have the app leave RAW images on the memory card in the camera but move or copy JPEG images to the tablet. This way, you can disconnect the tablet from the camera temporarily—without taking the camera off the tripod if it's on one—to show the images to whomever you need, then reconnect to continue the shoot.

On the Exposure tab of the app, set the image capture parameters to RAW+JPEG and choose the JPEG quality setting you want (**image 6.10**). Small or Medium should be fine for previewing on the tablet and will take less time to preview on-screen.

In the app, go to Settings>Image Saving and type the location where the JPEGs should be saved (**image 6.11**). The default is the Pictures folder, and this should be fine. The naming convention is, largely, irrelevant for this purpose; however, if you want to name the JPEGs for the particular client or project you are shooting, you can fill in the File Naming field. Similarly, the default folder name should be fine, but if

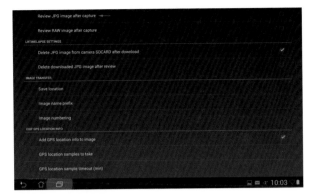

Image 6.12 ▲ Turn on JPEG Review (red arrow).

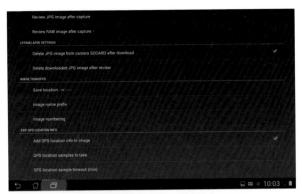

Image 6.13 ▲ Image Transfer/Save location options (red arrow).

you want to note it for the particular project, you can fill in the Folder Naming field. Further down the page the Download RAW Images After Shooting option will be left on Leave in Camera and the Download JPEG Images After Shooting option will be set either to Move to Computer or Copy to Computer.

With the tablet connected to the camera, take your test shot. Wait for the files to be written to the card and the tablet, then disconnect the tablet from the camera. To access the images, you can go to the stock Gallery app that comes installed with the tablet and the images will appear in the folder you set up in Helicon. You are now able to show the images to stylists, clients, models, or whomever you need, make adjustments to the shooting setup, then continue on. From here you can reconnect the tablet and use Helicon to capture more images or, with the setup as you need it, you can capture the images directly with the camera.

Using DSLR Dashboard. DSLR Dashboard works in a similar fashion to Helicon Remote. It is a wired connection to the camera, but you are able to capture JPEG images to the tablet and leave RAW images on the camera. You can also disconnect the tablet from the camera as needed to show others in the studio what the image looks like.

Go into the app's Settings menu and in Shooting Settings (keep in mind that English is not the first language of some developers), and select Review JPEG Image After Capture (**image 6.12**). In the Image

Transfer section, you are able to set up the location the JPEGs will be saved to, the naming convention, and numbering in the three fields (**image 6.13**).

On the main screen of the app, you are able to set the image capture option to RAW+JPEG and the size of the JPEG to be stored (**image 6.14**).

With these settings in place, you can go back to the app and begin capturing images. After you capture an image, the JPEG will automatically appear on-screen. The image will remain on-screen as long as you want. Tapping the back button on the taskbar will take you back to the app. If you want to review several images, tap on the image icon at the top right of the screen, which will take you into the appropriate folder on the tablet, giving you thumbnail images. Tap the image you want to review and it will pop up full size. The

Image 6.14 ▲ Image file type and JPEG Quality/Size (red arrows).

Image 6.15 ▲ Impressionistic photo of a blooming magnolia arching over a pathway in High Park, Toronto, ON. The camera was moved intentionally during the shot to create the effect. Nikon D700, ISO 200, .8 second, f/22, and a 2-stop ND filter.

navigation buttons at the top left and right of the screen are used to switch between images, and the back button on the task bar will take you back to the thumbnail previews.

▶ Editing on the Fly

We can also use PMR2 to edit images captured with any of these apps on the fly to give clients or models a quick preview of how the final image may look.

Downloading images using CamRanger is a bit slower than with the next two apps because you are downloading via WiFi. It is still possible, however, and the time difference is not significant.

Tap the Image Grid icon on the main screen of the app to move to the image-review screen. RAW images will appear with a small R in the lower-right corner. To download one or more of these to the tablet, tap the Save icon, then tap to select the images you wish to download. Tap Done, and the images will begin to download to the tablet. You are only making copies, not downloading the original image files.

There are no options for specifying the location of downloaded images. When you open PMR2, navigate to the folder, then go to the CamRanger folder. Here you will find the images you just transferred. You are now able to open the shots in PMR2 and make edits for preview.

To do this with Helicon Remote, we need to make a quick change to the settings in the app. In Image Saving, change Download RAW Images After Shooting to Copy to Computer. You can leave the JPEG settings as is.

Changing this setting will make a copy of the RAW file on the tablet in the previously set up folder. Now, switching to PMR2, we can open that copy and make adjustments to it to preview anyone we need to. Using a copy is preferred to moving the RAW file to the tablet because then the original RAW file is still untouched on the camera's memory card. The XMP file created can always be deleted when we get back to the office, but I think having a copy on the tablet and the original untouched on the memory card is preferable. It is also always possible to copy the XMP file from the tablet to the desktop later if you want to see those adjustments on your main editing screen.

The process in DSLR Dashboard is a bit different. With DSLR Dashboard you have the option, in the app, to view images that are resident on the tablet as well as on the memory card. You can toggle between by tapping the camera icon in the review area or the mobile device icon.

There is nothing to change in the settings of the app. In order to bring images from the memory card to the mobile device, long press on the Grid icon, which will effectively select all the images. You can now tap on the images you wish to delete from the download and leave the desired images selected. Now long press on the Download icon to activate it (it's the icon of the arrow with the line under it), then tap on one of the files that is selected. This will begin the process of downloading the selected images to the tablet.

You are only copying the images, so the originals will remain on the memory card. Once the images are downloaded onto the tablet, you can open PMR2 and begin editing and previewing.

▶ Lighting

Using a tablet as a light source? Really?! Yes, really. Now look, I'm not talking about lighting a full set with tablets or phones. But using them as a small fill for portraiture or as lighting for small product photography can certainly be done.

Lighting Apps. There are a couple ways we can use tablets as lighting sources. Two apps that are helpful in this regard are Softlight and Softbox. Both turn the screen of the tablet or phone into a diffuse light source. Both can be adjusted for brightness and color.

Softbox offers a texture option which I don't, personally, find overly useful. The most useful aspect of the app is in the color combination you can get with it. Entering the app, you will be presented with a set of RGB sliders. These allow you to create any color combination to get any hue of light that you want. You can also tap on the K icon, which will allow you to set the color of the display by color temperature. There is a slider as well as several presets. The Checkerboard icon allows you to choose from one of several

color checker patterns. There really is no use for these, so this area of the app can be ignored. The brightness or strength of the light is adjusted using the hardware screen brightness toggle on the phone or tablet.

Softlight is a much simpler app. Entering it, you are presented with three sliders. One is a hue control, one is a saturation control, and one is a brightness control. It's pretty easy to determine that the Hue control affects the color of the light. The Saturation control determines the intensity of the color, with zero in any hue being white. The Brightness control gives you the intensity of the light. Softlight is ad-supported, but the ads go away when you tap on the screen to hide the control sliders.

So, how do we use these things? As I mentioned, there are a couple of ways. They can be used in the same way that traditional lighting is used for small product photography. You can set them up on your set in the same way you would other lighting. These are not overly powerful lights, so you will have to keep them close to the subject. Tablets or phones of

Image 6.16 ▼ Nature wins. Vines growing on the side of a building in Oshawa, ON. Nikon D700, ISO 200, $^1/_{60}$ second, and f/8.

different sizes can be used to give you main and fill lighting. You can adjust the brightness of the displays to affect the lighting ratios. Devices like the X-Mount and C Clamp discussed in chapter 2 can be attached to a tripod and used to position the lights and hold them in place. Similarly, folio-style cases can be used to stand a tablet on the table where needed. This can allow for single-shot images to be captured.

Tablets or phones of different sizes can be used to give you main and fill lighting. You can adjust the brightness of the displays to affect the lighting ratios.

When using tablets and phones as light sources, make sure the batteries are fully charged and that the screen timeout settings are set to never turn off. This will help ensure that you have a good amount of time to work with the lights on the project and that one of the screens doesn't time out during a shot.

A second option is to use the devices to paint the subject with light. Depending on how the painting is done, this can be a single-shot technique or a multi-shot technique with the images blended later in editing. Multi-shot techniques are very common in product photography.

Tablets and Phones as Stationary Lights. In the image below (**image 6.17**), I used two devices—a 7-inch and 10-inch tablet. The tablets were set up in the support hardware with the larger one on camera

Image 6.17 ▼ Patriot Gauntlet WiFi hard drive lit with two tablets and lightbox apps.

left and the smaller, as fill, on camera right. I purposely used a larger aperture, f/4, for shallow depth of field, and the shutter speed was $1/5$ at ISO 100. My goal was to position the lights to create two strips of light on the hard drive—one across the name as the main and the other across the LED lights as the fill.

When using devices in this way to light a subject, there is no need to have the room entirely dark, as there is when using the painting technique. It is best to keep other light to a minimum and farther away from the subject so as to reduce or eliminate the difficulty of mixed lighting white balance issues, but complete darkness isn't necessary. The other product images in chapter 2 are lit the same way.

Light Painting. You do need to be in complete darkness when using the light painting method. You are going to be moving devices and your arms and hands through the frame while the shutter is open. If you have other lighting in the room, you and your phone/tablet will end up being in the shots. Not a good idea. You can even go so far as to wear a dark, long-sleeved shirt and dark gloves. I did wear a long-sleeved, dark shirt for the examples here but did not wear gloves.

The painting technique will take some practice to get right. You will need to experiment with shutter speeds and how to paint the subjects to create your highlights and shadows. If you are going to use a multi-shot approach and blend later, you will need to keep track of how you are painting so that you keep the light where you want it for each shot of the composite.

Start with the room lighting on so you can focus. When you have your focus set, switch to manual focus if you used auto-focus and turn off the room light. Either of the softbox apps mentioned earlier can be used. If the setup is not complex, start with a shutter speed of about 15 seconds and begin painting. Plan in advance how you want to move the light over your subject. Practice with the lights on so you can see what you are doing. You want to move the phone or tablet fairly quickly and build up light in any area with

Image 6.18 ▲ Product image painted with smartphone and lightbox app.

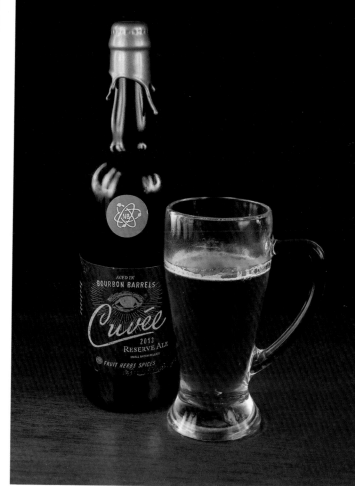

Image 6.19 ▲ Product shot, multi-shot Image. The bottle and glass were lit separately with a smartphone and lightbox app, then combined in Photoshop.

a series of strokes rather than holding the light in one place then moving it. Building up the light gradually will allow you to achieve a more even and smoother lighting of the subject. Holding the light in one place then moving it will cause hot spots and uneven lighting. This is really not much different from how brush tools are used in Photoshop or Lightroom to build up effects gradually for a smoother, more natural look.

When using a multi-shot method, there are a couple of ways you can approach it. You can establish the entire setup at once, open the shutter, paint part of it, then repeat it on other parts of the setup. Alternatively, if the setup includes multiple items (for example, a beverage shot that may have a bottle and glass), you can place both initially to determine your composi-

tion, then remove one while you paint the other. Then remove the first, place the second item in the set, and paint it. The two shots would be combined later in Photoshop using any of the popular layering and blending methods.

The advantage of doing the shot one item at a time is that you don't risk getting unwanted light spill or reflections onto or from other items in the composition.

I've included two examples. The first is a single shot (**image 6.18**). I used a shutter speed of 20 seconds and painted with my HTC One X phone. The second is a multi-shot (**image 6.19**). The bottle was shot with one image using a 20 second shutter speed, and the glass was shot separately also using a 20 second

shutter speed. The glass was placed in the freezer so that it would be nice and frosty and so that there would be some melting of the frost during the shot.

In Photoshop, I brought the two shots for the layered image in as separate images. Using the Crop tool, I simply cropped the image of the glass, leaving a good deal of empty space. I then copied the selection and pasted it into the other shot and lowered the layer opacity to allow me to position the glass where I wanted it. With the glass positioned, I raised the opacity back up to 100%. Next, I applied a Reveal All layer mask to the glass layer and, using a soft brush with a low opacity, I painted with black and cleaned up the blend between the two shots. You can then move ahead and make whatever other adjustments you want to the respective layers with Curves, Levels, Hue/Saturation, Layer opacity, and the like. Remember that if you're making an adjustment to the top layer and you want only that layer affected, you need to clip the adjustment layer to the subject layer by holding the

Alt key and clicking with the mouse on the line between the adjustment layer and the subject layer. You can also do this when creating the adjustment layer by holding the Alt key and clicking on the adjustment layer you want to create in the Adjustments panel. This will open up a dialog box that allows you to choose to use the layer beneath it as a clipping mask.

You could also do this by bringing the two shots in as layers in the same document. Then you would use the Brush tools and masks to hide/reveal what you want of each. In this case, I wanted the glass in front of the bottle, so I used the bottle shot as the base layer and the glass on top of it. If you wanted the reverse, you would use the glass as the base layer and the bottle layer would go on top. The order of layers impacts the overlap of elements. Whatever is on top will appear in front of whatever is below it in the layer stack. You can also use these techniques to do some interesting ghosting or image overlap tricks. If you want one image to appear as a ghost behind another, use a brush with a low opacity and paint in the area where you want the ghosted image to appear. You can achieve similar looks using layer opacity, but the opacity affects the entire layer. With the Brush tools, you can be selective.

Image 6.20 ▼ Impressionistic image of woods in autumn. The camera was panned vertically during the shot. Nikon D700, ISO 100, .4 second, and f/22.

Image 6.21 ▲ Shoulda made the left at Albequerque. Seven-shot HDR bracket taken at a wrecking yard outside Kitchener, ON. Nikon D700, merged and tonemapped in Photomatix. The shot was tonemapped twice, once for the car, once for the surroundings—then the two shots were blended and masked in Photoshop.

7. Mobile Miscellany

This is sort of a catch-all chapter. Things that did not seem to fit elsewhere but that I thought were important to discuss are included here.

▶ The Photographer's Ephemeris

The Photographer's Ephemeris (TPE) has been a popular desktop application for a number of years. The developers have migrated the app to the mobile world as well so it can always be at hand. TPE is a utility for planning shoots and tracking sunlight throughout the course of the day. It is a fairly complicated app but a worthwhile one as well. I'll walk through some of the functions that I consider most important.

The app has five screens that give different information. You scroll through the screens by swiping on the first gray bar below the map. The dots in the middle, darker-gray bar, indicate which screen you are on. The controls at the bottom of the screen are particular to each window of the app.

The first screen gives you sunrise and sunset data for a particular day (**image 7.1**). The light-orange line is the angle of sunrise. The dark-orange line is the angle of sunset. The light-blue line is the angle of moonrise. The dark-blue line is the angle of moonset. Tapping the single left or right arrow moves forward or backward by a single day. The multi-arrow moves backward or forward by a week, or to the next moon phase. Tap the diamond in the middle to return to the current date. The bottom-right corner of the information bar indicates the moon phase. Waxing is a growing moon, waning is a declining moon.

The second screen (**image 7.2**) indicates the different types of twilight. Twilight is different from sunrise/

Image 7.1 ▲ Sunrise/sunset data (red arrow).

Image 7.2 ▲ Civil, nautical, and astronomical twilight times.

sunset. There are several definitions for twilight, which is why there are three different measures. Civil twilight takes place from 6 degrees below the horizon. In the morning, it begins when the sun is 6 degrees below the horizon, and in the evening it ends when the sun is 6 degrees below the horizon. Nautical twilight is 12 degrees and astronomical twilight is 18 degrees. After 18 degrees it is dark. Twilight, of course, is that period of time when the sun is below the horizon but there is light in the sky. Many people think twilight is

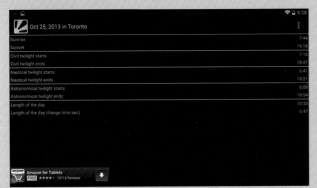

Image 7.3 ▲ Sunray information screen.

Image 7.4 ▲ Sunray preferences.

Image 7.5 ▲ Sunray city selection.

Image 7.6 ▲ Choose location by city name or GPS coordinates.

Sunray

Sunray is a simple and free (ad-supported) app that gives you sunrise/sunset and twilight times on a single screen (**image 7.3**). It uses the device's GPS chip to adjust the times to your current location. You still have to calculate the length of the twilight period, but you have all the information on a single screen, which makes this quite simple.

In the app Preferences (**images 7.4–7.7**), you can set Manual or Automatic mode. Automatic will give you the data for your current location and the current date. Turn on Manual mode and you get much more control. In Manual mode, you are able to change the location and the date. If you are planning on a trip and want to note sunrise/sunset and twilight times in your destination quickly and easily, use Manual mode. You can then go back to TPE and plan your shoots and time in more detail. I would advise leaving Update Day turned on when you are not planning a shoot so that the app will be giving you the right information when you are using it at any other time.

I used Sunray to quickly plan a shoot in Toronto for Torontohenge. It was quicker and easier than using TPE because all I needed was the sunset time for the given date.

Image 7.7 ▲ Date selection.

Why so much information on twilight? Simple. Twilight, or Blue Hour, is an oft-overlooked time to shoot. Outdoor photographers fixate on golden hour, that magical time in the morning and evening when you have long shadows and soft, golden, glowing light. Other photographers get stoked about night shooting and the often monochromatic scenes that can look quite surreal due to the limited and artificial lighting. But twilight is a great time to shoot too. There is still enough natural light that you can see more than just what is lit by street lamps or flash. But that light has a very interesting cool blue characteristic that can lend an almost ethereal look to images.

Image 7.8 ▲ Blue Hour in Dundas Square, Toronto. Shot with Rokinon 8mm f/3.5 fisheye lens on a Nikon D800. The exposure was f/6.3 st ¹⁄₅₀ second and ISO 100.

only a nighttime phenomenon, but it occurs both in the morning and in the evening. You will note that these times are different from the first screen. The first screen is when the sun is physically above the horizon and can be seen. That is actual sunrise or sunset. In

Image 7.9 ▼ Use the track bar (red arrow) at screen bottom to chart sun path throughout the day.

this window, the arrows at the bottom of the screen serve the same function as on the first screen. The length of twilight can be calculated by the difference between sunrise/sunset and the twilight times on the second screen, which are when twilight ends.

The third screen is where things get interesting (**image 7.9**). Using the swipe bar at the bottom of the screen, you can track the path of the sun and time throughout the day. At the far right is a small circle with a number inside. This switches from a 24 hour sun path to a 1 hour sun path. Being able to refine within an hour gives you very precise indications of where the sun be at a particular time of day so you can plan your shoot times accordingly. In addition to the angle, the information bar also shows the declination. Declination is a measure of the angle of the sun or moon above or below the horizon.

We get to have some real fun in the fourth screen. This is called the Geodetics screen. Geodetic data

is used by map-makers, designers of navigational systems, and similar professions to determine a place on Earth relative to other places on earth. That, on a much smaller scale, is what the Geodetics screen of TPE does too.

The Geodetics screen (**image 7.10**) gets into the real nitty gritty of planning a shoot. The red pin is your current location, or the center of the map. To position the red pin at your current location, tap the Compass icon in the upper-right corner of the screen. To reposition the red pin in the center of the map, tap the Pin icon in the upper right of the screen. You can reposition the red pin by long-pressing and dragging. The gray pin is another location, relative to the red pin. You position the gray pin manually by long-pressing and dragging. A single tap on the gray or red pin will indicate the longitude and latitude of the location of the pin. For using this tool, you are best to use the topographical map (I will explain why later), which you can switch to in the app menu. Go into Settings

Image 7.10 ▲ TPE Geodetics screen.

and select Map Type, then choose Terrain. This is the same as a topographical map.

Let's walk through an example of how you would use this screen. We will assume that I want to go to the Rocky Mountains in Alberta in October 2015 to shoot landscapes. If I am going to be in Alberta from October 10 to 15, I tap on Set Date and change the

Image 7.11 ▼ Long-term parking. Seven-shot HDR bracket taken at a wrecking yard outside Kitchener, ON. Nikon D700, merged and tonemapped in Photomatix.

Image 7.12 ▲ Tap Set Date to open the Date selection screen.

Image 7.13 ▲ Date screen.

Image 7.14 ▲ Tap Search (red arrow) to open the Location search options. Searches can be by name or GPS coordinates.

Image 7.15 ▲ Search box.

Image 7.16 ▲ Tap Add (red arrow) to save the location.

Image 7.17 ▲ The Save location screen.

Image 7.18 ▲ Tap Locations (red arrow) to open saved locations.

Image 7.19 ▲ Locations (red arrow). Timbuktu comes saved with the app.

date to October 10. In so doing, all of the sun and moon data is changed from the current date to the new date of October 10 (**images 7.12–7.13**). Tap Search to set a new location and type in the name of the place. In this case, I used Lake Louise, Alberta (**images 7.14–7.15**). The red pin is repositioned to that place. Tap Add (**images 7.16–7.17**) to name this location and save it. Saved locations (**images 7.18–7.19**) can be accessed in the future by tapping the Locations icon in the taskbar.

Continuing the planning, I am at Lake Louise and I want to shoot a mountain on the other side of the lake. I want the sun to start shining just on the top of the mountain. Using pinch to zoom, I zoom in on the area then I move the red pin to the objective (**image 7.20**). The objective is what I want to shoot, my subject. We move the red pin because that is the pin that the sun and moon information is tied to. The information bar shows me that the distance from my location to the objective is 2km. It also indicates that the elevation change is -412m and the declination is change is -11.5 degrees. All of this is positive for us, no pun intended.

The elevation change tells me that what I want to shoot is higher than where I am. The declination change, being negative, tells us that the sun will hit the mountain before it hits our location, which is the gray pin. The negative declination is consistent with the mountain being higher than where we are and showing a negative vertical difference. We can determine the time at which the sun will hit the top of the mountain by moving the time bar back until the sun angle matches the declination change. In this case, it will be 6:52AM, or about 1 hour and 15 minutes before sunrise at our location. The reason the sun will hit the top of the mountain before it hits us is because the mountain is higher. Think of many of the sunrise or sunset mountainscapes you have seen pictures of. It is often the case that the top of the mountain is in sunlight and the foreground is in shadow. At the higher elevation, the sun will be visible earlier or later than it is at a lower elevation.

Image 7.20 ▲ Red pin moved to objective location, gray pin is at original position.

Image 7.21 ▲ Checking sun on foreground.

What is also important to note is the angle of the sun. By looking at the light-yellow line, we can see that the sun will be angled very nearly along our shooting line from the end of the lake to the mountain top. At actual sunrise, the angle will be much more oblique.

We can also determine how much of our foreground will have sun at the time we want to shoot. Pick up the red pin and drop it somewhere in your foreground area (**image 7.21**). In this case, I dropped the pin in the middle of Lake Louise. We see that the elevation change compared to where we are is a mere 8 meters, so basically flat. The important number is the declination change. The declination change is now positive, but the sun is still 11.5 degrees below the horizon. This tells us that our foreground area will be in shadow when the sun hits the top of the mountain.

Image 7.22 ▲ App settings to change map type.

This is what we would intuitively expect, but TPE gives us the tools to more precisely confirm it. We can see when the sun will hit the lake by moving the time-line forward. At 8:03AM, or basically normal sunrise time, the sun will begin to hit the lake.

There is a caveat to all of this—and this is why we want to use the terrain map (**image 7.22**): The app looks only in a straight line from one point to the other; it does not know what is in between the two points. If another, higher mountain is between the two points, then the information will be incorrect because despite

Image 7.23 ▼ Sun Surveyor home screen.

Image 7.24 ▼ Main mapping screen with tools (red arrows).

the fact that the sun will hit the objective before it hits your location, you will still be blocked in your view by the higher mountain in between. The terrain map has elevation lines that inform you of the height of objects between where you are and your subject.

▶ Sun Surveyor

Sun Surveyor is similar to TPE. It works differently but has many of the same functions and some that TPE does not. The free version only provides sun information; the paid version has both sun and moon data. From the home screen (**image 7.23**) you have several tools that can be used. Shoot planning is done in the Map View and AR View screens.

Navigation in the map is done with pins, like with TPE. The way you move the pins is with the icons in the lower right of the screen. The Lock icon allows you to move the point around which the sun and moon data are calculated. This is where the map is centered (**image 7.24**) and is the same as the red pin in TPE. Your position is adjusted with the Pin icon— effectively the gray pin in TPE. It shows as a pin with a flat line below it when the location can be moved and as a pin with an X under it when the location is locked. With both pins locked, you can move the map around for a better view. With both pins unlocked, you can adjust the map center without also creating a relative path from a position pin. Moving the pins is done by long-pressing and dragging.

The relative positions of the two points you have set up are in the upper right of the screen. In this case, we can see that the distance is 1.3 miles. The elevation figures show the elevation of the objective pin on top and your location pin on the bottom. In this case, we have a difference of about 1,500 feet with a downward angle of 12 degrees (**image 7.25**). This tells us that the point we want to shoot to is higher than where we are shooting from, so the sun will hit that point before it hits us. The same caveats apply here as with TPE and using the Terrain map so you can determine what may be in the way between you and the point you are shooting to. I am using the same Lake Louise, Alberta,

Image 7.25 ▲ Pins positioned, information on declination, distance, and elevation change visible.

Image 7.26 ▲ Shadow length ratio (red arrow).

Image 7.27 ▲ Timeline slider (red arrow).

Image 7.28 ▲ 3D Compass utility.

Canada location as I did with TPE. The numbers may be off slightly due to not putting the pins in the exact same spots.

Sun Surveyor has an interesting feature that TPE does not. It has a shadow length ratio (**image 7.26**). This is an indicator of how long shadows are relative to the height of an object. When the sun is below the horizon or directly overhead, the ratio is 0. As the sun angle increases toward the horizon, the shadows get longer. A ratio of 1:1 means the shadow is the same length as the height of the object. Greater than 1:1 means longer shadows than the height of the object and less than 1:1 means shadows are shorter than the height of the object.

At the bottom of the screen is a Timeline slider (**image 7.27**). Here you can select from one day, one hour, or one year timeframes. Scrub along the slider to change the information in the data panel at the

lower left. To see the actual movement of the sun, turn on the Sun in the app Preferences. Now, as you move the Timeline slider, the virtual sun will move across the map. This is useful, for example, in determining what time the sun will be in a position you want it. With this feature and using a map of Manhattan, New York, you could plan for the phenomenon known as "Manhattanhenge." Twice a year, during sunset, the sun aligns perfectly with the main east/west streets of Manhattan. The same effect can happen in any city that has an east/west grid pattern and a clean view to the horizon, but Manhattan is best known for it. Toronto also has Torontohenge.

The 3D Compass feature (**image 7.28**) of Sun Surveyor will show you where in the sky the sun will be at different times of the day. We know that the sun rises in the east and sets to the west. But what some people may not know is that in moving from east to

Image 7.29 ▲ Augmented Reality view.

west it also moves to the south. This is why southern exposures get more sun than northern exposures.

You will not get the true sense of what this feature does with your device sitting flat on a table. Hold the phone or tablet up and, as you move it, you will see the arc of the sun and the moon relative to the position you are in at that time. Rotate the device and you will see the arc paths move with you. This 3D compass will give you a way to visualize in three

dimensions where the sun or moon will be relative to your position at any time of day. It would be really cool if this could be overlaid on a map, right? That is where the AR View comes into play.

Sun Surveyor has an interesting feature called AR View (**image 7.29**). AR stands for augmented reality. It works through the camera on the device to provide you with a view of what you are looking at in that moment. In the iOS version, it also allows you to overlay sun and moon positions on images from Google Maps Street View, but that feature is not in the Android version—at least not yet.

There are two ways to use the AR feature. Both involve the timeline scrubber at the bottom of the screen and can be useful in planning a shot. Let's say you are setting up a video shoot in an urban midtown area.

Image 7.30 ▼ Impressionistic image of a wooded area in Enniskillen Conservation Area, Enniskillen, ON. Short, looping camera movements were used while the shutter was open. Nikon D700, ISO 200, 1 second, and f/11.

Image 7.31 ▲ App settings.

Image 7.32 ▲ App settings.

Image 7.33 ▲ App settings.

Image 7.34 ▲ App settings.

There are buildings of varying heights around you. As the director of photography on the shoot, you want to know when the sun is going to go behind a certain building and when it will reappear.

By simply holding the device vertical, you will see a green line on the screen. Use the timeline scrubber to move forward in time to see when the sun will be at a specific place in the sky. This only tells you where the sun will be at a specific angle; it does not tell you how that angle will affect you. To determine that, you can use the sun arc that can be overlaid on the screen. That is the yellow arc described earlier. You will need to move the device around to keep that arc in view. It may involve some odd angles, but the information provided is useful. What you are doing here is finding out how high the sun will be in the sky. This will tell you whether, in fact, it will be obscured by the building you are concerned about. If the sun's arc never

Image 7.35 ▲ App settings.

goes behind the building from your vantage point, then you are never going to be in shadow during your shoot. If the arc does intersect with the building, then you can accurately determine for how much time the sun will be lost to you by continuing to move the timeline scrubber and moving the position of the sun. Pretty slick!

▶ Google Sky Map

Sky Map is a neat tool for viewing the night sky. It helps you identify or find stars, constellations, or planets.

Point your device at the sky. The app will use the GPS sensor in the device along with compass data to determine where you are pointed and will then show you what is in the sky above you (**image 7.36**). As you move the device, the view changes to show what is in the sky at the particular time in that specific area. Sky Map can also help you find a certain star or planet.

Using the search feature, type in what you want to find. Point the device at the sky and an arrow will direct you to what you searched for. As that item comes into view, the circle will change color and get larger. The searched item will also be blinking on-screen (**image 7.37–7.40**).

Sky Map is a good app for astrophotography. It can be used to help you orient your camera. It can also be used to help you find a specific astronomical feature that you want to track using a tracking mount and telescope.

Image 7.36 ◀ Sky Map showing stars/constellations.

Image 7.37 ▼ Sky Map menu bar.

Image 7.38 ▼ Sky Map search criteria.

Image 7.39 ▲ Directional indicator.

Image 7.40 ▲ Search item located (red arrow).

Image 7.41 ▲ Sky Map preferences.

Image 7.42 ▲ Sky Map preferences.

Image 7.43 ▼ Raindrops on the leaves of a hosta in my backyard. Nikon D700, ISO 200, ¹/₆₀ second, and f/11.

Image 7.44 ▲ Fast Photo Notes options screen, Add New or Append to Existing.

Image 7.45 ▲ Adding notes to a photo.

▶ Fast Photo Notes

There are times when you are out somewhere shooting and you want to remember some detail of what it was you were doing. Paper notepads are passé. You may be able to record a note using a voice recorder app, but then you have to match the audio note with the proper image.

Fast Photo Notes allows you to append short text notes to photos. You can be snapping away all day long with your DSLR and when you want to remember something, use your phone to take a picture then append the note to it.

Opening the app, you have the choice to select a new or existing image. If you choose New Item, the app will prompt you for which camera app you want to use. Select the camera app, take the picture, and tap the checkmark. You will then be taken back to the app, where you can add text in the appropriate field. Tag wildlife photos with the species. Add a note about a particular landscape shot. If you are using a film camera and want to remember the exposure settings, you can add those in the cell phone shot. Later, after you have scanned the film, you can append the exposure information into the metadata using Bridge, Lightroom, or another EXIF editor.

This brings us to the end. You are now ready to go out and be a fully mobile photographer. Enjoy the journey.

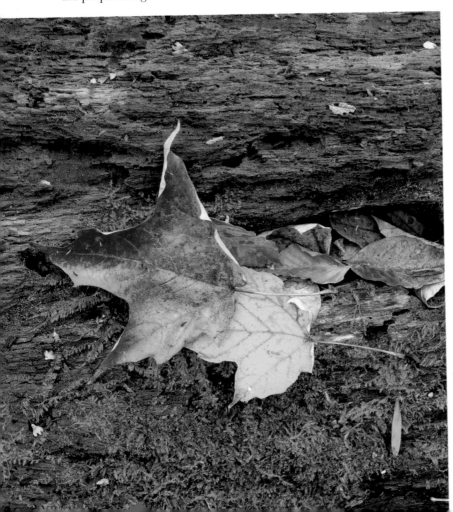

Image 7.46 ◀ Leaf on a decaying log. Nikon D700, ISO 200, .8 second, and f/11.